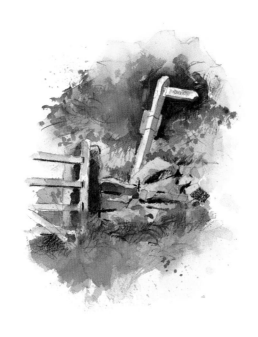

Watercolour
in Close-up

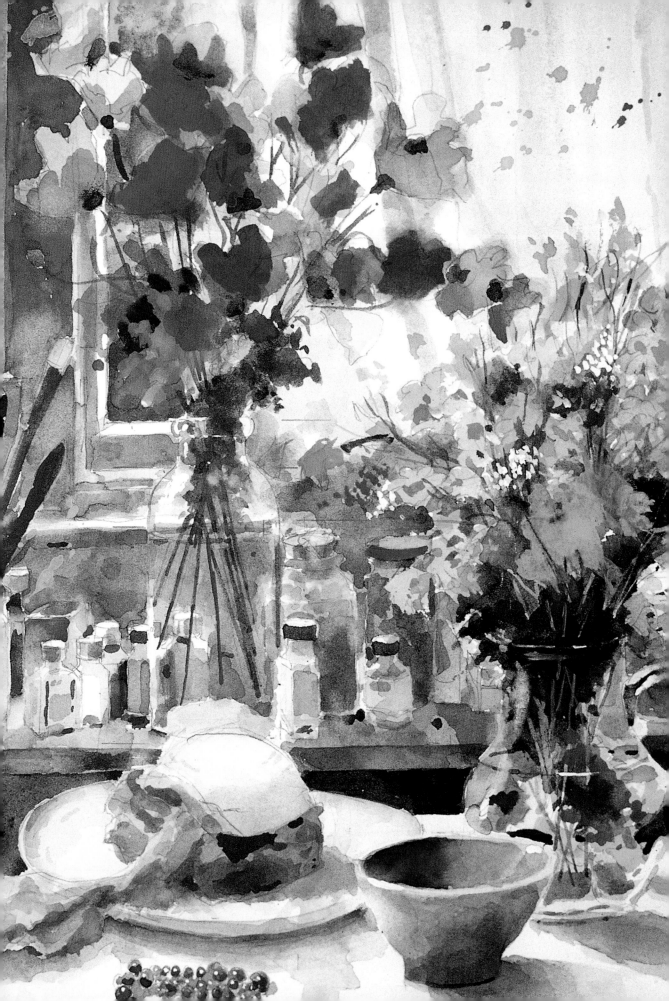

Collins

Watercolour
in Close-up

John Lidzey

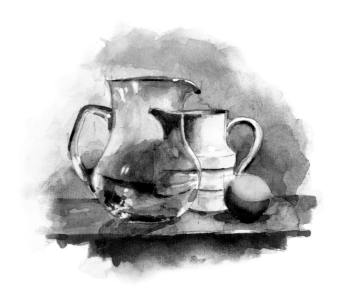

Very many thanks to all the people who helped me with
this book. I would especially like to thank my wife, Elsie,
for all her help and forbearance to the end.

First published in 2004 by
Collins, an imprint of
HarperCollins*Publishers*
77-85 Fulham Palace Road
Hammersmith, London W6 8JB

The Collins website address is
www.collins.co.uk

Collins is a registered trademark of
HarperCollins Publishers Limited

05 07 08 06 04
2 4 6 8 7 5 3 1

A catalogue record for this book is available from the British Library

Created and designed by:
SP Creative Design
Editor: Heather Thomas
Designer: Rolando Ugolini

Photography: John Lidzey

ISBN 0 00 715806 8

Colour reproduction by Colourscan, Singapore
Printed and bound by Imago, Singapore

Contents

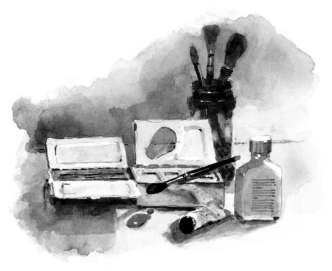

Introduction

When I first began to paint in watercolours all too many years ago I was attracted to painting views. I painted in the countryside, in towns and on some holidays by the seashore. I suppose that I was trying to pass on the feelings I had for beautiful scenery or atmospheric city streets. But as the years have gone by, I have found myself more attracted towards subjects of a smaller scale. I now find that subjects as diverse as a half-open gate, a girl reading on a railway station platform or even a patch of weeds can say something more intimate and intuitive than perhaps larger-scale themes and subjects.

This book is an attempt to indicate just a few of the small-scale subjects that have interested me and which might be found, sometimes in the most unlikely of places. In addition to this, I have suggested how they might be sketched or painted with notes on methods, which colours to employ and the best use of materials.

Watercolour is a medium that is ideally suited to painting close-up subjects. It can be used if necessary to describe detail down to the finest of dots, and to recreate complex surfaces and textures limited only by the artist's skill.

▼ **Interior with Jug and Bowl**
33 x 43 cm (13 x 17 in)
China and glass can make a fascinating study, especially when painted against the light.

Close-ups of peeling paint and rusty metal offer no challenges to the medium. Equally, the watercolour process can be used to evoke the movement of air or to depict sea water breaking against beach defences.

An additional advantage of watercolour is its suitability for sketchbook working. Close-up subjects can be studied easily and unobtrusively on location. Sketches can be made often in the busiest of places, in towns perhaps, and then, supported by photographs, they can be used at home or in the studio in the production, if desired, of a larger-scale painting.

Most of this book is devoted to subjects that might be painted from a relatively close distance and I hope I have made some useful suggestions. However, it is important to stress that what you paint is not as important as how you paint it. Many, maybe most, people who buy a painting will do so because they like the look of it, not because of the subject. I have admired paintings of what might be regarded by many as quite boring subjects but which are nonetheless absolutely beautiful. I have also seen poor paintings of fascinating subjects which have just left me cold. The aim of the watercolour painter should be to create a painting that is aesthetically pleasing in spite of the subject.

The last section of this book departs from the matter of subject and looks at how you can develop your watercolour. It begins by showing how to create a measured and reasonably accurate drawing. Using the method I outline, you can become a successful practitioner, but you should practise for maybe 15 minutes every day. Drawing is not learnt only by reading about it. I also focus on paint application, light, tone and colour which are important considerations in creating interesting, vibrant watercolours.

▶ **Girl Waiting for a Train**
51 x 34 cm (20 x 13¹/₂ in)
People on station platforms can make ideal subjects as shown by this girl waiting for an underground train.

When searching for something to paint in close-up, you could reject those subjects you consider visually interesting and instead look for something that might be passed over. Look for ways of making a painting work, perhaps by using free brushwork or different textures. Colour and tone might be altered to create unusual effects. Keep a lookout for good close-up subjects and, when you find one, think about it creatively to produce a painting everyone would like to buy.

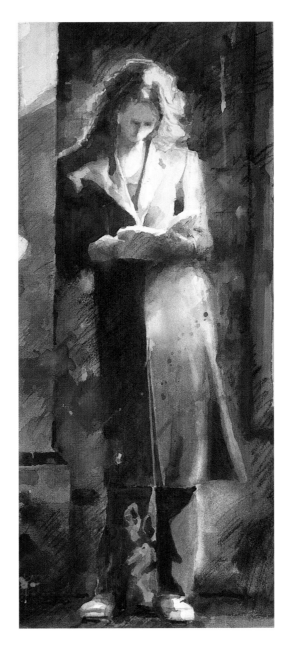

Materials

You do not need a vast range of expensive materials to become an accomplished painter. You can produce some beautiful watercolours with some relatively modest equipment.

Paints

You can buy watercolour paints in tubes or pans. Artists' quality is always best but get Students' quality if money is short. A useful workable palette could be made up from no more than

▼ *I have had this paintbox for nearly 20 years, and it has served me very well, both in my studio and on location on my travels abroad. You will need a variety of different coloured paints and brushes together with china palettes for mixing, paper and a sketchbook.*

a dozen colours: French Ultramarine, Monestial Blue, Yellow Ochre, Cadmium Yellow Pale, Cadmium Yellow Deep, Aureolin, Cadmium Red Deep, Alizarin Crimson, Indigo, Payne's Grey, Burnt Umber and Coeruleum. A tube of Permanent White is often useful for adding highlights and in other places where just a touch of white is required, but do not overuse this paint. Too much can spoil a watercolour.

Brushes

It pays to get Kolinsky sable brushes if you can afford them. Otherwise go for a sable and ox hair blend. A good set for a beginner would be as follows: Round brushes Nos. 2, 6 and 8 together with a mop brush, 12 mm (1/2 in) wide.

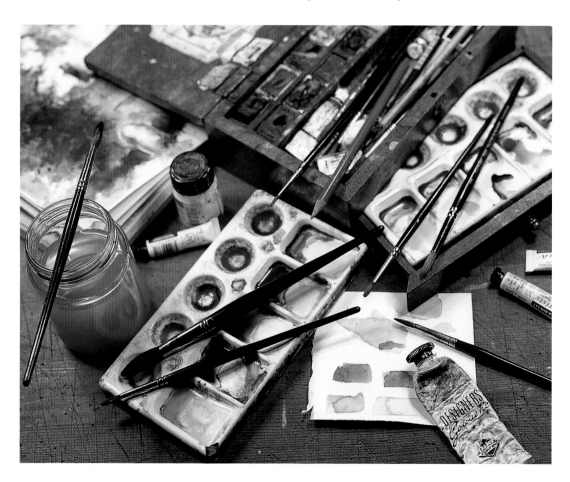

Paper

There are many kinds of watercolour paper for the artist. They are sold in sheet form, usually 775 x 572 mm (30$^1/_2$ x 22$^1/_2$ in), and are available according to their method of manufacture, weight (thickness) and surface, i.e. Rough, Hot Press (smooth) and Not (somewhere between Rough and Hot Press). A good paper for the beginner would be Not surface, 300 gsm (140 lb).

Many watercolour papers can be bought in pad form in a variety of sizes. The smaller ones can be convenient for sketching on location but, because they are usually ring-bound, the pages often come adrift. The most enduring ones are those that are bound like an ordinary book but with pages of a good-quality cartridge paper, which is suitable for watercolour. Some useful sizes to have are either 24 x 15 cm (9$^1/_2$ x 6 in) or 15 x 10 cm (6 x 4 in). Make sure that the paper inside is not so flimsy that it will cockle when watercolour is applied.

Drawing tools

Obtain good-quality pencils, preferably 2B, 4B and 6B. For sketching purposes, 9B pencils can be wonderful to use. Get a pencil holder for heavily used (short) pencils; it will avoid waste and save you money. Putty erasers are the best erasers as they will not damage the paper surface. You can use them also to clean up smudges and general grubbiness.

◀ *The author at work in his studio. On the wall behind him is some of his recent work.*

Other materials

Scalpels are most effective for sharpening your pencils to a good fine point when necessary. They are also useful for cutting down sheets of paper. A cutting board is a real boon when used in conjunction with a scalpel. It will prevent damage to surfaces and furniture.

Small china palettes can also be useful and are preferable to plastic ones which can make mixing difficult, especially when new.

There are numerous felt nib pens, now with waterproof ink. They are available in thin and thick versions which can be used in conjunction with watercolour.

Art masking fluid is a very useful substance, applied with a pen or brush. Keep it securely stoppered or it will become hard and difficult to use. You may also need some cotton wool for mopping out and cleaning up watercolour while wet. It can also be used for lifting out dry paint.

▼ *Sketchbooks are useful for working in many types of media, including pencil, pastel, conté crayon and watercolour. The smaller (closed) sketchbook is very convenient as it will fit into most pockets.*

Useful Techniques

Learning all the watercolour methods, techniques and 'tricks of the trade' will not necessarily make you a good practitioner. Painting is much more than this. However, some knowledge of how paint behaves and how it can be manipulated can certainly be useful in making a start.

The following techniques show some of the ways in which paint can be applied to paper, how it can be lifted off and also how other substances and media can be used to create a variety of effects. Try and see for yourself.

Wet-in-wet

This term means the act of painting on previously dampened paper or painting on top of undried paint. Beautiful effects may be obtained when working this way where one colour bleeds into another or where characteristic marks occur which are distinctive to the process. Wet-in-wet, however, does not permit any degree of precise working.

▶ *A typical effect of the wet-in-wet process. Marks like these are known as runbacks.*

▼ *Wet-in-wet method: using this, atmospheric watercolours are quite possible.*

Wet-on-dry

Painting onto dry paper or onto previously dried paint is what is meant by this term. Because watercolour paint when laid down onto dry paper (or other colours) will normally form a very sharply defined edge, paintings of great precision may be obtained. It is also possible by this method to overlay the same colour successively to build up a rich, low-toned result.

▲ *Wet-on-dry method: a subject like this can be painted with colours butting up to one another. Each colour was applied only after the last one had dried.*

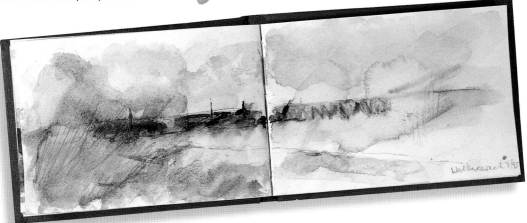

Lifting out paint

It can be possible to remove wet or dry paint on many papers, either with a brush, a sponge or cotton wool. It is a useful technique for painting skies and many other subjects.

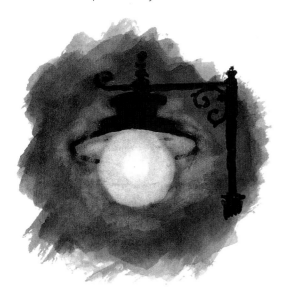

▲ Lifting out paint: a hole cut in cartridge paper was laid on dry paint, and the paint was then removed with some damp cotton wool.

Masking fluid

Small areas in a watercolour wash which are needed to be kept free from paint can be masked with art masking fluid, applied with a brush or pen. This is available from all good art shops.

Building up colour

The traditional method of painting in watercolour is to begin by laying down pale washes of colour. On top of these, when dry, further colours are laid down where necessary to provide darker hues. Through the course of the painting, light and dark tones emerge. Avoid painting too many layers of paint as muddy colours could result.

▶ Building up colour: green watercolour was painted in successive layers on previously dried pigment. The dark area on the left has four layers of paint.

Scraping out

Using a very sharp craft knife or scalpel, paint can be scratched out to reveal the white paper surface underneath. Scraping out can be useful for suggesting highlights, such as on water subjects or glassware. It can also create certain effects in landscape work.

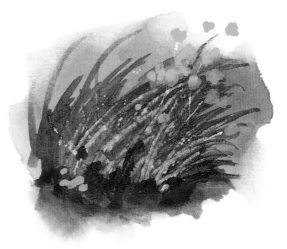

▲ Scraping out: in this example, some paintwork was scraped out and a light wash was then laid over parts of the area to suggest grass.

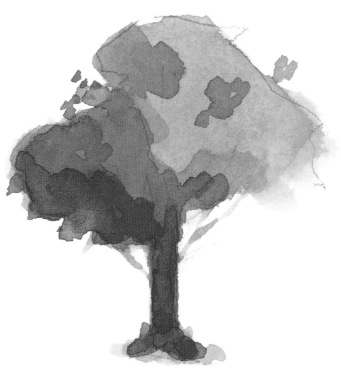

Printing

Many implements may be used to apply paint to paper in a way that would be impossible with a brush. A wire mesh, for example, painted with watercolour and pressed down on a paper surface can create a texture that might have uses in certain subjects. Many painters have a collection of similar items which they use in their work.

Wax resist

Candles, wax crayons and even beeswax may be used to exclude paint from paper. Rubbing a candle over paper prior to painting can create the basis for textures when paint is laid. Beeswax applied with a knife can provide fascinating effects, such as suggesting rough and rocky ground.

▲ Printing: a ruler, a finger and a nail head have been used here to create these useful marks.

▲ Candle wax: rub wax over a dry paper surface and paint over the top. Dramatic results are possible.

Gouache

This paint is similar to watercolour but has additives to make it opaque. It can be diluted to behave in a very similar way to watercolour. Titanium White gouache can be used for creating small highlights in paintings of china or glassware. Do not over-use gouache in a watercolour if you want to retain its luminous quality.

▶ Gouache: highlights on bottles are created with some gouache mixed with only a little water.

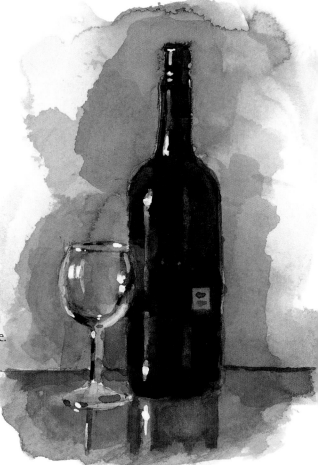

Creating textures

There are numerous substances that, when added to paint, can produce painterly effects in their own right or which can imitate particular material surfaces or geographical features.

Soap Mix paint with soap and it disperses in a curious fashion, creating blobs of paint, bubbles and rings. Use it to add interest to flat washes.

Oil and water resistants Turpentine, white spirit and petroleum jelly can be used to break up paint to give a marbled texture. Use petroleum jelly with soap and concentrated paint to create fascinating dark areas of colour, but only use old brushes when working with this substance.

Salt Drop crystals of sea salt into wet paint. When it has dried, brush off the crystals and the result can look like snowflakes or have a mottled effect resembling a rocky surface.

▶ *Soap: by brushing a small amount of pigment freely into some soapy water, you can create some very textural marks.*

Impasto gel This substance, which is obtainable in tubes, can be added to watercolour to give some of the qualities of oil paint. By learning to manipulate the mixture with a brush or palette knife, you can obtain all kinds of useful textures.

▼ *Impasto gel: rough ground and tree foliage were suggested here with impasto gel manipulated with a piece of card and a sharp knife.*

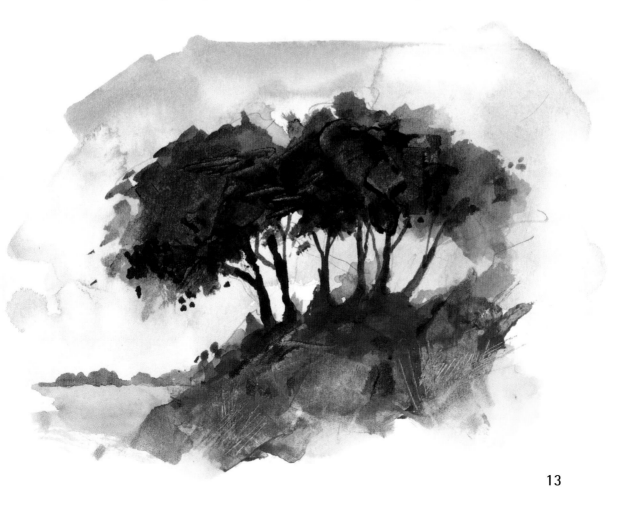

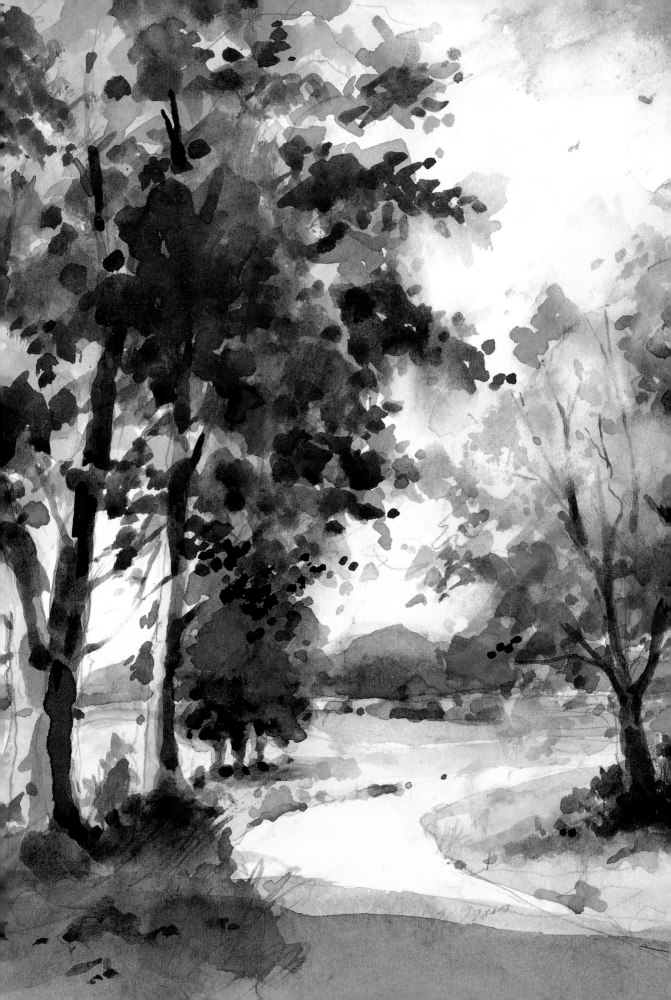

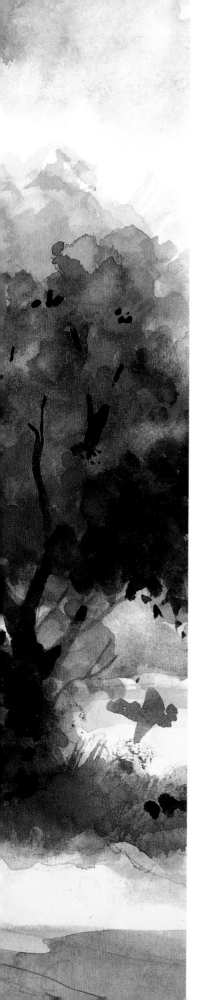

In the Countryside

The countryside offers some beautiful, paintable scenery. Perhaps this is the reason why so many watercolourists are attracted to painting rural subjects. Fields, hills, farmhouses, meadows, lakes or woodland can all make you want to get out your painting kit. But painting a scene or a view is not the only option. Many small-scale countryside subjects can also be a delight to paint – things that the aspiring landscape painter can often pass by without noticing.

Gates, signs and farm machinery can be good to paint; even a piece of fencing covered in ivy can have the makings of a splendid watercolour. In summer, wild flowers growing in neglected corners can make a marvellous subject. In winter, something as simple as the bare branches of a tree against an evening sky or ditches, dykes and stiles make attractive themes. Why look for grand vistas when small and often insignificant subjects can inspire beautiful paintings?

◀ **By the River Waveney**
38 x 35.5 cm (15 x 14 in)

Sketching in hidden places

Subjects can often reveal themselves in totally unexpected spots, and this is especially the case with wild plants which often thrive in hidden places. Common flowers, or even thistles and briars, are attractive to paint. Some good places to look for such subjects can be neglected field corners, in woodland, the crumbling brickwork of a barn or even growing out from inside some old abandoned farm equipment.

Using a sketchbook

Small-scale subjects are often best recorded in a sketchbook. By working in this way, you can adopt an informal approach. Your sketches can be loose and not detailed, delightfully free and uninhibited. It can certainly be a very enjoyable experience to spend a morning out in the countryside just making sketches. Develop the habit, and the skills that you obtain will feed into your considered watercolours.

Materials

You do not need a large sketchbook. I have found a 24 x 16 cm (10 x 6 in) book, when closed, a suitable size. A hardback cloth-bound

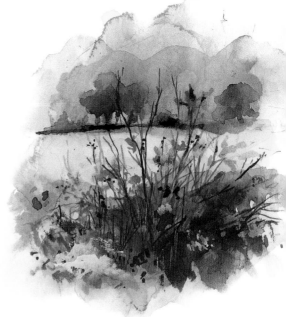

▲ **Weedy Corner**
13 x 13 cm (5 x 5 in)
Even an unprepossessing patch of weeds at the side of a field can be worthy of study. You may not need to go very far to find a subject like this.

book is ideal – it can be kept in your coat pocket or a bag and will withstand really rough usage. Avoid books with thin paper; a good 190 gsm cartridge is probably best, but a slightly heavier-weight paper would be acceptable.

You may well find that if your sketchbook is of the size recommended, no more than two brushes might be required – a No. 4 and a No. 8 round brush. For paints, travel light and take one of the small boxes that are now on the market.

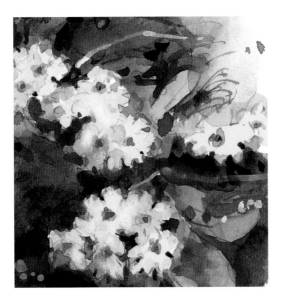

◄ **Primroses**
14 x 11.5 cm (5 x 4¹/₂ in)
A simple study which was made at speed. The flowers were painted first and when the paint had dried the surrounding vegetation was built up, layer on layer, to achieve a strong contrast of tones.

Sketching technique

Remember that you need not produce highly finished work. Aim to record just shapes and colours with a minimum of real detail. It is amazing how splodges and dots of paint can take on an organic quality. It is not necessary to paint flowers with botanical accuracy or to define leaves clearly. Experiment with your colours while you are on location, and, when at home, seek ways to create paint that suggests plant life rather than actually describing it. Work from your imagination, too. You will learn to paint more effectively by regular sketching than by steadfastly working at home, painting from photographs.

▼ **Gatepost**

25 x 18 cm (10 x 7 in)

Even potentially uninspiring subjects can be interesting. The dotted and blotted watercolour helps create an organic feel. White gouache mixed with Cadmium Yellow has been added over the top of colour washes.

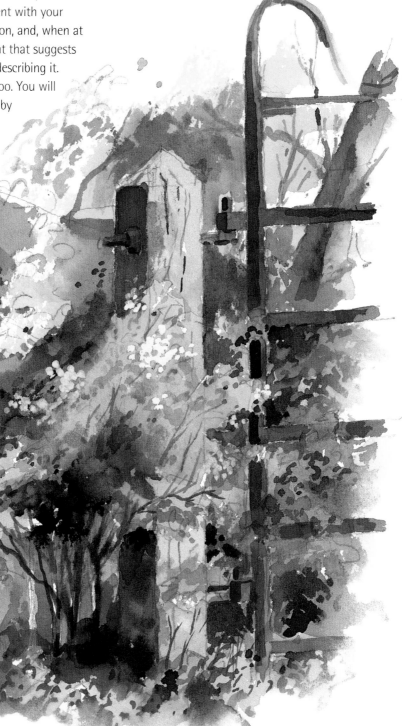

Flowers and plants

The use of herbicides has, in many cases, severely reduced the growth of flowers in fields and sometimes in hedges. Nonetheless, against all the odds, it is still possible in summertime to find poppies, campion, ragwort, ox-eye daises, rose bay willow herb, speedwell, and cow parsley growing in uncultivated corners. In the spring, on banks and verges, primroses and cowslips growing in abundance can be a sight to behold.

Variegated washes

The watercolourist is lucky to have a medium that can so easily suggest a wild ground cover of leaves, stalks, grasses and other organic matter. Variegated small washes of dots and dashes of paint made with a brush, pen or even a fingertip can produce a surprisingly realistic effect. Do not be tempted to paint just one or two wild flowers rather like botanical specimens. Treat them rather as clusters or masses growing in their natural habitat. Begin by making some rough sketches, if you can get in close, and take some

photographs. From these you may find it easier to work at home to produce a finished result. Opaque white gouache mixed with watercolour will enable you to paint most flowers over the top of the ground cover (see page 12).

Using pen and wash

In close-up, grass can often be suggested with a mixture of watercolour washes and the use of a pen, together with nibs of varying widths. If you have handy a bottle of fresh masking fluid, which will flow easily off a pen nib, then this will provide you with an additional means of obtaining a realistic effect.

▼ **Wild Corner**

25.5 x 33 cm (10 x 13 in)

The painting began with a free wash of pale blues and greens. Masking fluid was applied with a bamboo pen (see page 25). Darker washes were then applied over the top. The yellow flowers were overpainted with white gouache mixed with Cadmium Yellow Deep.

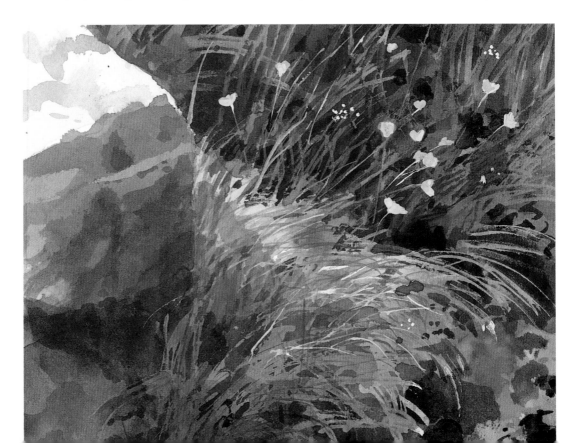

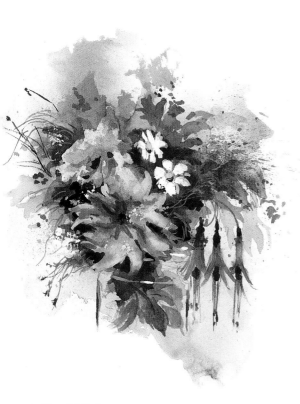

▲ Floral Mixture

20 x 20 cm (8 x 8 in)

Flowers, grasses and leaves provided a good opportunity here for free paint application. Although this study is loose and a little crude in parts, a sense of the organic nature of the subject is conveyed.

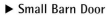

▶ Small Barn Door

25.5 x 7.5 cm (10 x 3 in)

Even some straggly weeds can add interest to an ugly farm building. In this study I overpainted the leaves and stalks using browns, greens, violets and yellows. Notice how Cadmium Yellow Deep as a watercolour is opaque enough to cover a low-tone wash.

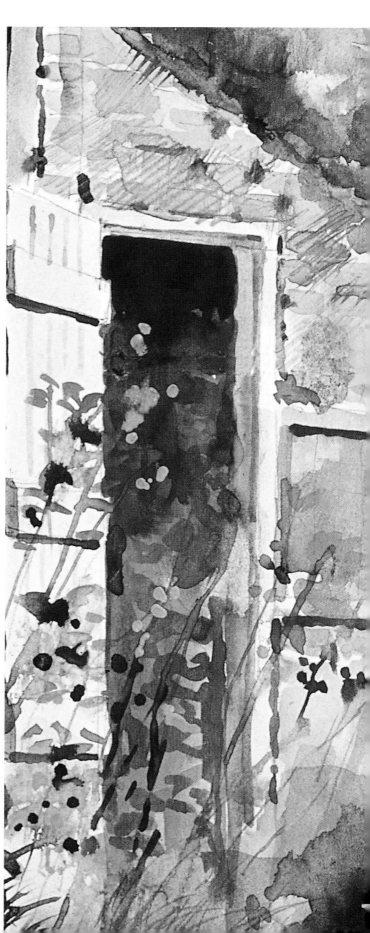

Trees in mixed media

One of the most fascinating and enjoyable subjects to paint in the countryside is a small group of trees. Without necessarily showing the surrounding landscape, trees can often make wonderful watercolour paintings.

If used carefully, watercolour can suggest delicate foliage and branches. Wet-in-wet techniques with splatter and calligraphic brush techniques can create beautiful, luminous work. Watercolour on its own can, in the right hands, be effective, but if it is combined with other media and is used with freedom and vigour, it can become exciting and dynamic.

Adding other media

Watercolour can be used very successfully with gouache, pastel, carbon pencil and even charcoal. When describing vegetation, it is often an advantage to use one of these materials over the top of a watercolour wash. If you are working quickly, in a sketchbook perhaps, conté crayon or carbon pencil hatched over dry areas of paint can suggest long grass, small branches and twigs. Alternatively, white gouache or pastel can be employed to create a satisfactory impression of lush growth.

▶ A 3B conté pencil was used for the branches with charcoal applied over the watercolour wash.

▶ Paint branch structures with a No. 4 round brush. Practise creating them using a series of lines with slight changes of direction, width and paint density.

Remember that using this mixed-media approach is not meant to create a photographic representation of the vegetation but merely to suggest it so that the viewer of the painting is allowed a share in its interpretation. If you are intent only on reproducing exactly what you see, your paintings may be accurate but may also be unexciting. Whether you are using watercolour on its own or with other media, above all, be adventurous.

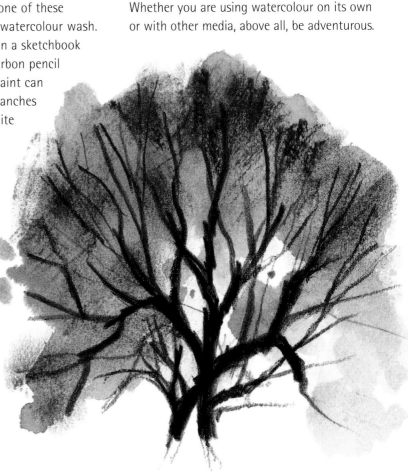

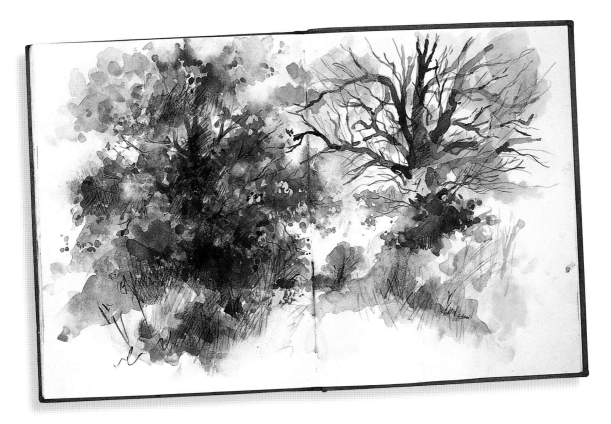

▲ *A very quickly made sketch, painted with a No. 8 round brush. Watercolour washes were flooded onto the page with concentrated mixes applied over the top when dry. Carbon pencil scribbled over the painted surface gives the sketch an impromptu and vigorous quality.*

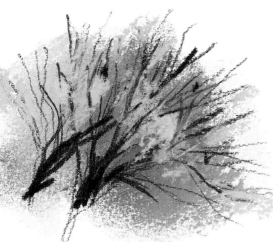

▲ *These branches were drawn in 3B conté pencil over soft coloured pastel with additional lighter colours applied over the top.*

▶ *This foliage was created with some watercolour pencils, softened with clean water brushed over the top. Branches were drawn afterwards with a 3B conté pencil.*

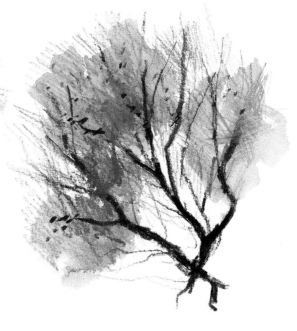

Composing a tree painting

Few landscape subjects ever offer a ready-made composition just waiting to be transcribed onto paper. To achieve an interesting result, it will often be necessary to involve yourself in a little rearrangement of nature. For instance, when painting a small group of trees, it may well be useful to alter the spacing between them or to change their size relative to one another.

Additional features that might be changed could include the actual shape of the trees and the amount and colour of their foliage.

Before starting on a painting, it may be a good idea to make a series of sketches which are based on the subject but suggesting alternative compositions. These need not be carefully made; they could be just 'blocked in'.

Preparatory work of this sort can be of great help in achieving a satisfactory final watercolour but, more than this, it can enable you to develop the ability to produce lovely little studies which could be worthwhile in their own right.

Chance encounters

With luck it is sometimes possible to come across an arrangement of trees that seems to form a perfect self-contained composition. In this case, at least make a quick drawing of what you see in your sketchbook. Such studies can often suggest finished paintings, produced later at home or back in your studio.

▲ *Trees of similar shape, size and position can result in visual monotony. When you are presented with such an arrangement, you may need to improve on nature.*

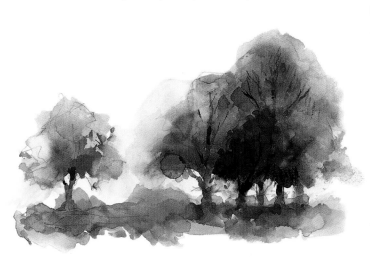

▲ *This arrangement looks more interesting. It has variety of size, density, colour and, above all, spacing.*

▲ *If you find an interesting tree composition, make a quick sketch of it and keep it for future reference; you may find it comes in useful one day.*

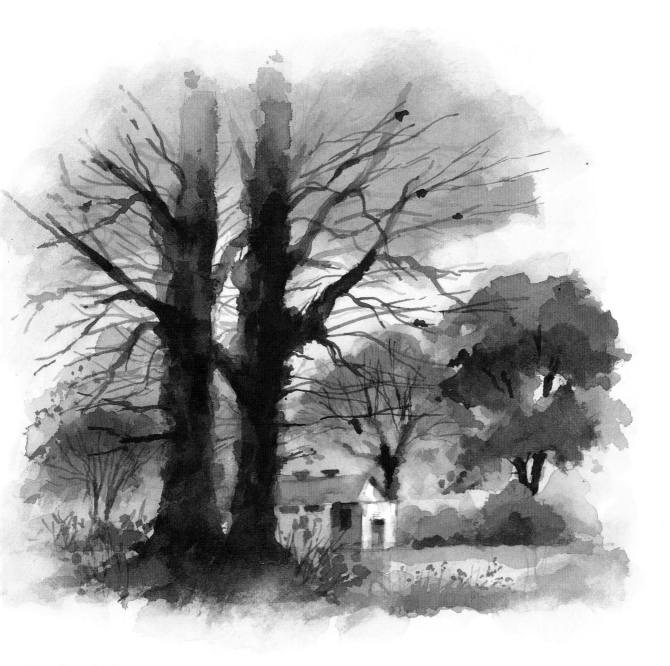

Creating depth

A good way to achieve depth in a landscape is to select a subject with both close-up and distant features. You could include foreground grass, bushes or even trees. The difference of scale between close-up and distant features will help create a sense of recession. Photographers often use this device to achieve dramatic results. The painter is at an advantage here as the problems of focus and depth of field do not arise.

▲ **Trees at Flixton**
25 x 30 cm (10 x 12 in)
Positioning trees in the immediate foreground of a painting and contrasting them against more distant trees will create a sense of depth and perspective. Foreground low tones and lighter background tones will also contribute to this quality.

Close-up on foliage

A common lament of many watercolourists, and other painters also, is that they have problems with depicting trees with convincing foliage. This difficulty seems to spring from the fact that trees have so many leaves. However, as with so many problems that arise in painting, the answer lies in the reduction of detail. The degree to which detail is simplified is usually dependent on the distance from which the subject is viewed.

Leaving aside the matter of distant trees, those that occupy a position that might be described as relatively close might be painted with no more than uneven washes of colour,

whereas really close-up foliage certainly calls for more detail but not to the extent of painting every leaf. It is not easy to be more specific than this. The treatment of foliage, near or far, is a matter of creating a convincing result within a style which is the painter's own.

▼ *The foliage of trees in medium close-up can be suggested with washes of colour. You may be able to see where water has been dropped into concentrated colours and allowed to run. Techniques like this can give looseness to a sketch while contributing to the impression of organic growth.*

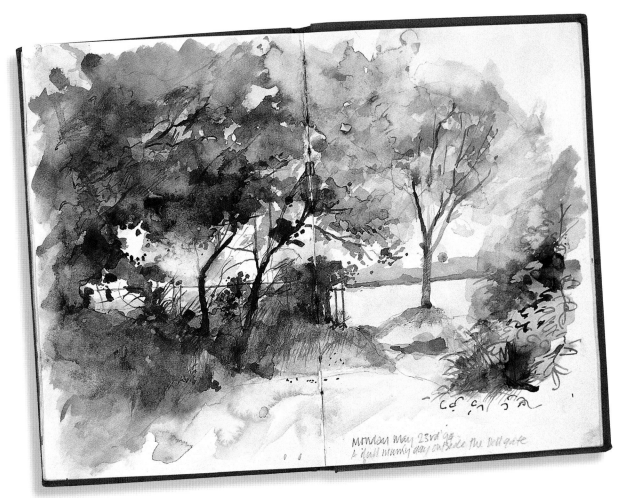

Foliage in medium close-up

With the use of a pen and variegated washes of colour, it is possible to create quite plausible-looking foliage. Dropping water into wet paint, together with amounts of concentrated colour, using warm and cool greens, can achieve a convincing result. A broad-nibbed pen can add unspecific detail. Practice is required to obtain fluency of line, and it can be a good policy to make a habit of painting small areas of foliage using this method. Use small scraps of paper or a small sketchbook and work at it often.

With regular application, you should find that your efforts will achieve success and that, in time, your watercolour technique will develop a style of fluency and expression.

Foliage in real close-up

In a similar way, practise painting foliage with blended brush strokes. The effect of working this way can achieve a high degree of realism. But, above all, make a point of studying how other painters obtain their foliage effects. 'Borrow' their techniques and adapt them to your own ends.

▲ *Close-up foliage can be suggested by laying wedge-like shapes over a flat wash using a No. 8 round brush. Painting darker shapes over lighter ones will help to give the foliage apparent depth.*

▶ *When moving in close it may be seen that in many trees leaves seem to form in bunches. In this quick pencil sketch, some shading has been added to give a sense of form and shape to the foliage. Using a pen and wash, you could make a watercolour version of this.*

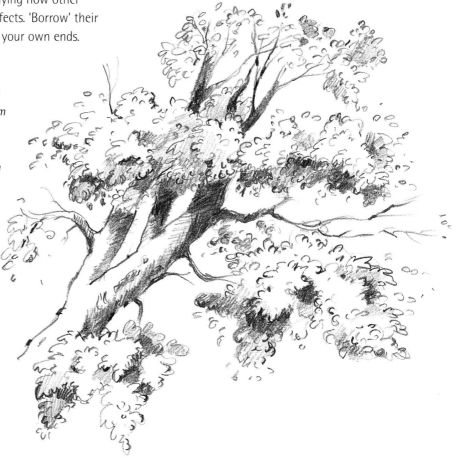

Painting farm animals and wildlife

Whether you are an inexperienced painter, or even a practised one, you will find a camera a most useful tool for painting farm animals. Even that most static of creatures, the cow, will not stand absolutely still for an artist, and at least a camera solves this problem. However, sketching farm animals can be a very rewarding experience, although for many inexperienced watercolourists a sketch does not provide enough reference for a finished painting.

People who have lived with farm animals all their life may well have some instinctive knowledge of their structure and anatomy even if they have never drawn them. Anyone coming fresh to close-up animal painting may need recourse to photographic techniques, and this is especially the case with wild animals. For animals such as foxes, deer, squirrels and birds, some photographic reference is a virtual necessity.

Using your imagination

If you aim to use photography as a basis for your painting, do not just take a photograph and copy it; doing this will only result in a stilted painting. You need to create a watercolour that has a non-photographic look. This may be achieved in a number of ways. You can use free brushwork with wet-in-wet techniques to represent animals; this will give life to your painting. Alternatively, you can introduce other features into your

▼ **Fox at Dusk**
15 x 23 cm (6 x 9 in)
This fox is as might be seen in a wildlife book but the environment is completely made up. Watercolour and conté have been used to create this untamed-looking landscape. Creating landscapes from nothing can be a rewarding activity and can nurture your imagination.

painting such as trees or other vegetation drawn from life. Or you can simplify your painting of an animal, leaving out its fine detail and even showing it in shadow. Another method is to create a completely different, yet compatible, setting for the chosen animal. You can use your imagination, adapt imagery from landscape photography or use references from your own sketchbook. If you can do any of these things, you will be able to call your watercolours your own and not just copies of mere photographs.

Sketching

Sketching farm animals can often be a difficult undertaking but, in spite of this, it can be fun and, what's more, it can help to develop your powers of observation and your ability to get your drawings down on paper – quickly.

▼ *A photograph could be the reference for this kind of study. By adopting a loose painting style, it can be possible to create a sense of movement which is often not shown in the frozen moment of a photograph.*

▲ Grazing Cows
20 x 23 cm (8 x 9 in)
You could paint farm animals in one spot and then create a background from a different location. The trees in this painting came from an adjoining field.

Rivers and streams

Inland watercourses can take many forms: anything from small shallow streams to mighty rivers. Their waters can flow slowly or gush in torrents. Water can reflect dazzling sunlight or, in the shade, it can be just murky. When getting in close, all of these forms require different techniques to convey their particular qualities.

Water and light

In many cases, clear water appears to be just like a mirror. Depending on the angle from which it is viewed, it will reflect the sky, in which case it can be painted in the same, or a similar, tone and colour. One way of painting the sky reflected in water is uneven washes of a pale colour which suggest the sky above without actually matching it.

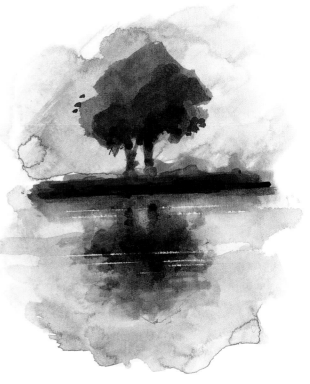

▲ In some circumstances, an absolutely perfect reflection in water can look unnatural. In this case, slightly breaking down the image will create a more effective result. Parallel lines scratched on dry watercolour can suggest reflections of light in the water.

▼ Moorhen in the Reeds

14 x 25 cm (5¹/₂ x 10 in)

Masking fluid can sometimes be used to good effect in water subjects, as in this river reed bed. The masking fluid was applied with old (past their best) brushes (Nos. 4 and 6). The water splashes were created in the same way with a little help from white gouache.

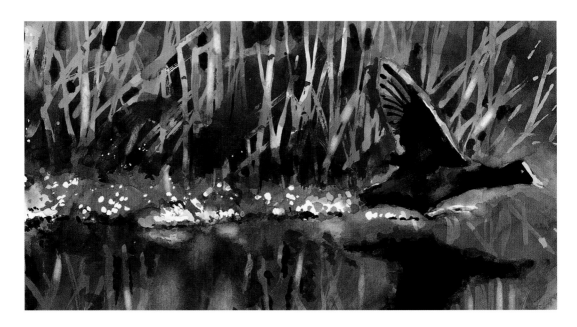

Effective results come about where the water reflects the sky but the sky is not included in the painting. The sense of light can be quite powerful, especially where parts of the water and riverbank are in deep shadow.

Water and reflections

An absorbing subject for the watercolour painter working in close-up is one where water reflects features from the land. Still, clear water can reflect pin-sharp and static images. If you are presented with such a subject it is often better to suggest a slight amount of movement in the water so that you avoid showing an identical inverted image. A good way of doing this is either to break up the reflection by giving the edges a slight wobble or even to represent them in a somewhat broken form. The important thing is not to make your reflected images become too elaborate. It is always better to show less than more!

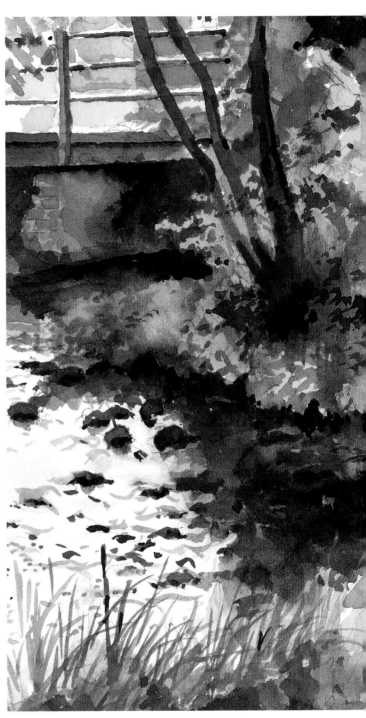

▲ **Fast-flowing Water**

14 x 11 cm (5¹/₂ x 4¹/₂ in)

Fast-flowing water can be suggested by blues and greens built up one over the other. Some masking fluid, flicked on before the painting begins, can create the effect of spray.

▲ **Tunbeck Brook**

24 x 14 cm (9¹/₂ x 5¹/₂ in)

This is a shallow, fast-flowing stream surrounded by dense undergrowth and bushes. In the shadow areas, to the right, the bed of the stream can be seen. To the left the water is acting as a mirror, reflecting the light from the sky.

DEMONSTRATION: The Waveney at Bungay

Rivers and river banks can often be gloomy, especially on dull days, and if such a subject is painted from nature a rather spiritless result might follow. One solution is to make a drawing on the spot, then paint the subject later at home or in the studio, using colours that are lighter and brighter than those that are found on site.

1 *This drawing was made from sketches and a couple of bad photographs taken of the river bank. Much detail was left out deliberately to allow improvisation during the painting process. For the drawing I used a 3B pencil with a sharp point.*

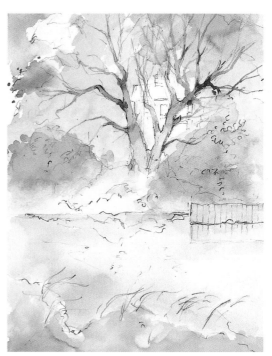

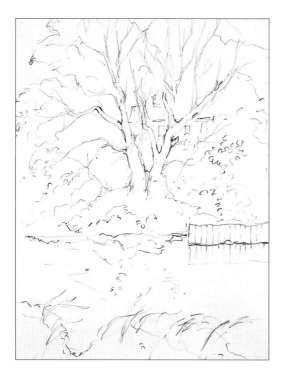

2 *I began by laying washes of pure colour, using French Ultramarine, Monestial Blue, Yellow Ochre and Cadmium Yellow (Pale and Deep). I then mixed greens and browns from these colours which were used for the tree trunks and some of the foliage. For the river, a very pale uneven wash of French Ultramarine was laid down.*

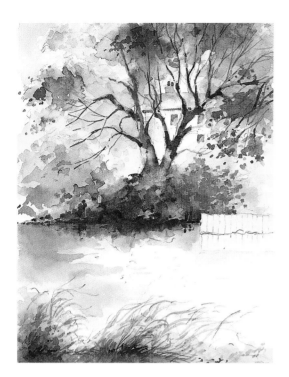

Focus on details

▲ *I have used tone here to create a sense of depth within the painting. The tree is painted darker than the distant roof and window. Distant features should normally be lighter than close-up ones.*

3 Further washes of yellowish browns were laid over the foliage on the left and a darker green on the right. Further mixes of Monestial Blue and French Ultramarine were laid on the left of the river. I darkened many of the tree branches using Payne's Grey and Cadmium Red. The reeds in the foreground were painted with a No. 4 round brush using Indigo and Aureolin.

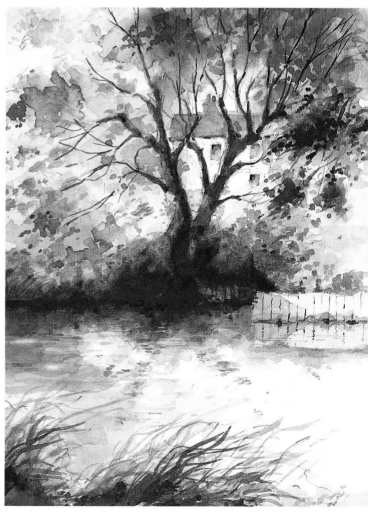

▶ **River Waveney at Bungay**
30 x 20 cm (12 x 8 in)
This last stage involved selectively darkening the tones of the tree, the river bank, the river and the foreground. The river patchily reflects the sky and I have suggested an area of shadow on the left as a reflection of trees from out of the picture area.

Gates and fences

Gates viewed up close can make a marvellous subject for the close-up watercolourist. Possibly the best ones are those that are struggling with nature, either shrouded with weeds and covered in moss or even disintegrating into the last stages of decay. A well-maintained gate simply does not (in most cases) have pictorial appeal.

For reasons of farming technology, field gates are becoming less common nowadays and it is quite difficult to find one that is good to paint. When time is short it is often worthwhile to keep a sketchbook handy to make at least a quick study as reference for a more finished painting later in the studio.

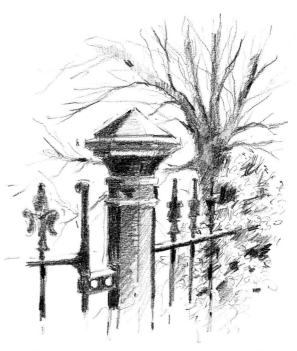

▲ *Your sketchbooks could contain drawings of details like these. There is enough information here for a possible watercolour to be painted back in the studio.*

▼ *I made this sketch from the comfort of my car. Subjects like this, with a few modifications, can be the basis for later paintings.*

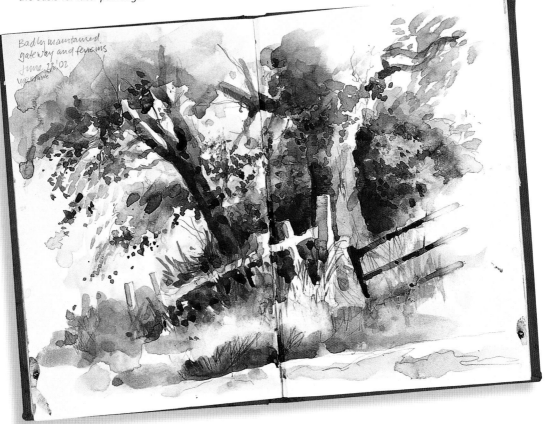

Mixing and using greens

Watercolourists who live and paint in more northern latitudes sometimes have difficulties with the unremitting green colours that occur in landscape subjects. When presented with so many green features – trees, grass, undergrowth, for example – in some circumstances, the painter may have a problem. Using too many green colours, especially if they have a high density, can lead to a painting that does not please. Partly because of this problem, some painters are drawn towards painting autumnal scenery or, in other cases, are attracted to subjects further south where greens become yellower or cease to exist at all. You can cope with this green difficulty by exploring the possibility of using varieties of this colour: mixing a range of warm greens to complement some of the colder versions.

One way of putting this into practice with gates and fences is to use warmer yellow/greens in the foreground and to employ the cooler blue/greens further back. This, however, is not intended as an inviolable rule and there are many cases where the opposite may apply.

▶ **Cadmium Yellow Deep/French Ultramarine**: *greens and yellow greens mixed from these two 'warm' colours will never be bright.*

◀ **Aureolin/Indigo**: *some beautiful yellow/greens and greens can be mixed from these. They are good organic colours.*

▶ **Windsor Blue/Lemon Yellow**: *the yellow/greens and greens created from these two colours will produce slightly cold colours.*

▼ **Field Gate**
18 x 25 cm (7 x 10 in)
Overgrown and seldom used gates like this one can make a good subject for a watercolour. White gouache, mixed with Cadmium Yellow Pale and Monestial Blue, was used for the grasses with white gouache for the flowers.

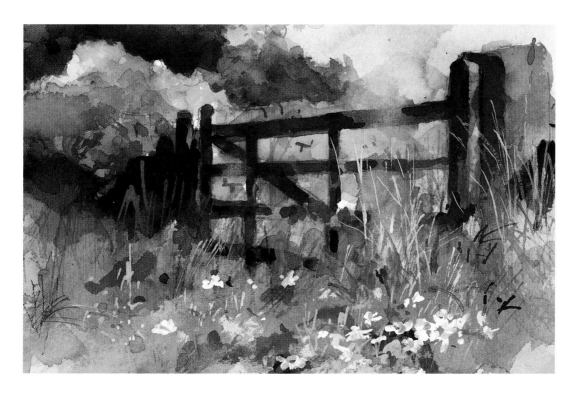

Meadows and farmyards

The value of junk and discarded items as subject matter for paintings has been underestimated. Beautiful things do not always necessarily make beautiful paintings; often the reverse applies. Many country farmyards provide fascinating subject matter. In some can be found machinery or equipment which has been displaced by more up-to-date items. Left lying in a neglected corner, they gather rust and become overtaken by weeds, but neglect of this kind can certainly have a picturesque value.

It could be that some farmers are somewhat defensive about their discarded technology so it is probably best to ask their permission before entering their premises and to point out to them exactly what you want to do. Once you have gained their approval, it is best to keep things as you find them rather than to rearrange the farmyard equipment in the interests of your pictorial composition.

Working quickly

It often pays to paint subjects as quickly as you can – not for practical but for artistic reasons. If you are faced with a close-up subject, an old plough perhaps, half hidden by weeds, what you might see is a mass of detail: flowers, leaves, stalks and seed heads, not to mention the complications of the farm machinery. The temptation can arise to paint everything exactly as you see it and this will take hours! Set yourself a short time limit to complete

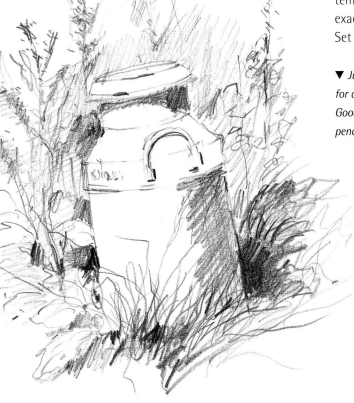

▲ *This churn was dumped in a ditch. It was just asking to be drawn. I used a 4B pencil for this sketch. It gives better details and acceptable small areas of low tone than other pencils, such as the 9B above.*

▼ *Just a series of random objects can be good material for a sketch. I used a 9B pencil for most of this drawing. Good strong darks can be achieved with really soft pencils, such as these. They are lovely to use.*

whatever you intend to do: drawing or painting. This means you will have to cut out detail. The best way to achieve this is to simplify the subject by looking at it through half-closed eyes. Aim to transfer what you see this way into paint. A clump of weeds becomes a splash of green. A foreground bale of hay is reduced to a colour wash with superimposed rough brush strokes. Machinery is simplified right down into basic shapes. Paintings produced with speed often look more interesting than those you labour over.

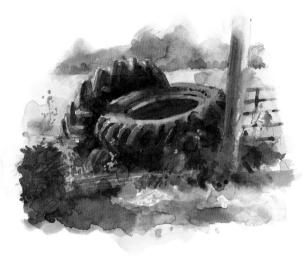

▼ Abandoned Tractor

18 x 22 cm (7 x 8¹/₂ in)

Cannibalized and left to rot in an overgrown field, this tractor made a good subject. Note how the weeds have been simplified down to little more than splashes of colour.

▲ *Subjects like these old tractor tyres are easily passed by yet they can make for an interesting watercolour. This can be achieved by using a good range of light and dark tones and allowing the paint to flow freely.*

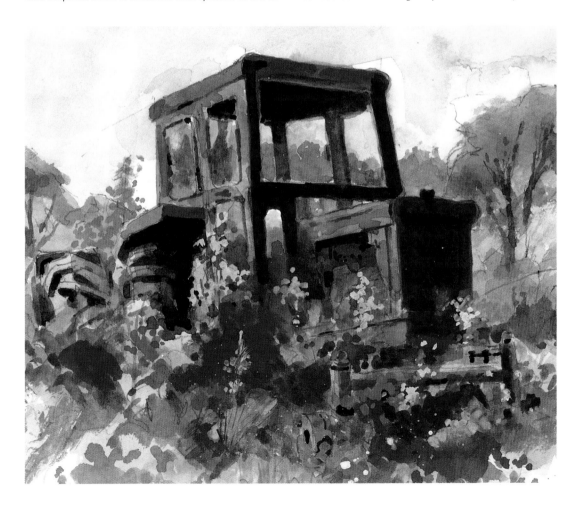

On the Seashore

Many watercolourists have found inspiration by the seashore, the most popular subjects perhaps being coastal views or panoramas of sea and sky. However, there is an alternative to such large-scale themes – subjects of a narrower dimension which can be just as interesting to paint and can often possess equivalent aesthetic appeal. Here are a few examples: the sea crashing against rocks, breakwaters, piers and sea defences. In a harbour, even more subjects offer themselves: birds, boats, ropes, nets and rigging. At the sea's edge, there are crabs, seashells, starfish, anemones and many kinds of interesting seaweed, while on the beach you will find children exploring rock pools and people sunbathing or taking a nap.

The watercolourist has plenty of subject matter here so keep your eyes open for the unusual, the insignificant and even the half hidden. Use your imagination and there is no reason why you should not produce watercolours which are much more satisfying than mere sea views.

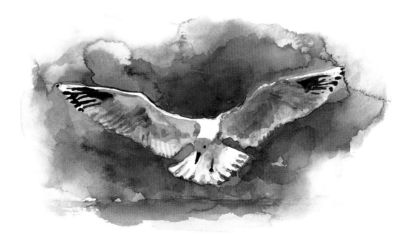

◀ **On the Suffolk Coast**
28 x 26.5 cm (11 x 10¹/₂ in)

Breakers and waves

The sea, with all its moods, can be a wonderful subject for the watercolourist. It can be painted on a stormy day rather than a tranquil one, perhaps with mountainous seas under an uneasy sky. The drama of such rough seas can give you ample scope for an exciting painting on a grand scale, but painting panoramic views is not the only subject for the aspiring painter.

A close-up of waves crashing against coastal rocks can also make a splendid theme. However, although watercolour might be the best medium for painting such subjects, the practice of recording sea spray and waves on the spot could pose a problem. One solution favoured by many artists is to make rough sketches on location for general reference and then to produce more finished work at home or in the studio.

Sea effects

A rough sea breaking against rocks will usually throw up wild spray. Three possible methods might be used to suggest this effect on paper.

Reserving This involves merely painting the sea, sky and rocks around the areas defined as spray and leaving the spray itself unpainted. The result can be surprisingly effective and certainly worth some experimentation.

◀ *A simple pencil sketch like this could be all that is needed in order to produce a more considered painting later on back at home or in the studio.*

▶ **Stormy Seas**
15 x 20 cm (6 x 8 in)
The white waves and foam in this study were created by leaving some portions unpainted. The spray was created by flicked white gouache. Some wave tops were softened by rubbing out with damp cotton wool.

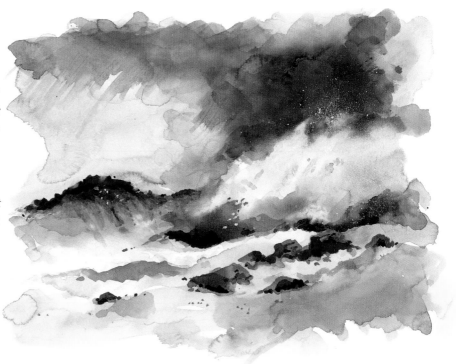

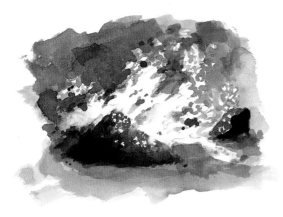

▲ *Reserving: draw the areas in which you wish the spray to be shown. Merely paint up to these areas. You can keep some control of the painting by blotting out or rubbing out watercolour where needed.*

Masking fluid The fluid can be flicked from a stiff bristle brush, but it can also be laid down as flat areas where necessary. When the masking fluid has dried, you can start your painting. Afterwards, the masking fluid can be rubbed off with a (clean) finger and the spray is thus revealed. However, using this method can be somewhat hit and miss as, on removal of the dried masking fluid, the result can often be quite different from what you expected.

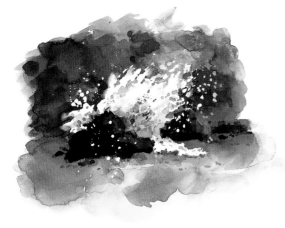

▲ *Masking fluid: it is always best to use only fresh masking fluid which is loose and runny – over time, this substance is liable to become thick and quite difficult to handle. Over the areas of plain white paper where the masking fluid has been removed, the paint may be applied as required.*

White gouache Using this method can be quite exhilarating! Titanium White gouache paint (obtainable in tubes) can produce some really spectacular effects. Having produced a painting showing waves but no spray, you simply load white gouache on to a stiff-bristled brush (even a toothbrush would do) and flick the paint, using a forefinger drawn over the bristles to create spray effects as desired. If necessary, white gouache can be painted in where you wish to show areas of white foam. Happily, any mistakes with the gouache can be removed with a piece of damp cotton wool or kitchen paper.

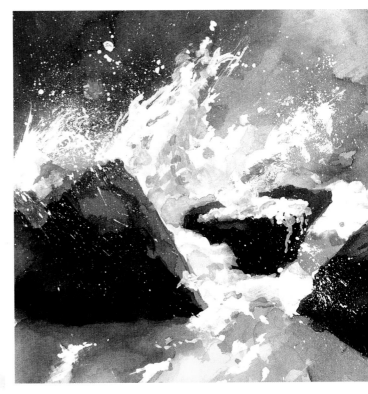

▲ *White gouache: mix the gouache with only a little water to the consistency of thick soup. This will ensure that a realistic spray effect is achieved. Use too much water and the result will be a white with insufficient density.*

Sea birds

In order to find an interesting subject for your sketchbook you need only make for a harbour when the fishing boats arrive. Gulls, wheeling, soaring and looking for a share of the catch, can be good to draw or paint. On the beach, however, gulls can sometimes be attracted with bread thrown into the air – with a few slices, you could have hundreds above your head in a moment.

Drawing sea birds

To make a drawing of a bird in flight might seem difficult if not impossible. In the case of seagulls, it is possible to identify the shapes that they make in flight and to jot these down in your sketchbook. The ability to see shapes, memorize them and then commit them to paper can be developed with some practice. Indeed, you could create a series of typical outlines which could be kept for future reference.

Using photography

Another method of drawing such subjects is to use photography, especially when you need to gather details that cannot possibly be obtained through observation from life. An attractive photographic reference of a bird, or birds, in flight can suggest an idea for a watercolour which could never have had its basis in a sketch.

A photograph should only ever be used as a reference, not something to copy slavishly. It often happens that a watercolour that originates from a photograph which is traced down and painted dot-for-dot is stilted and lifeless. If you do use a photograph, you should aim for the finished painting to be in some way different from the original photograph. You could make alterations of spacing, placing, tone or colour or even, in the case of painting sea birds, think of creating an alternative background which can be painted from your own observations rather than from the existing photograph.

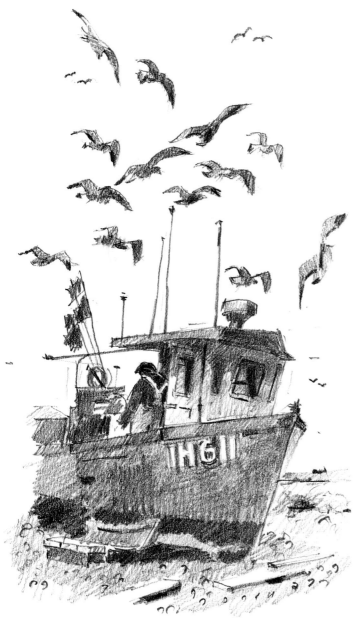

◀ *Above the fishing boat in this pencil sketch I have drawn seagulls in silhouette which were taken from some existing studies in my sketchbook.*

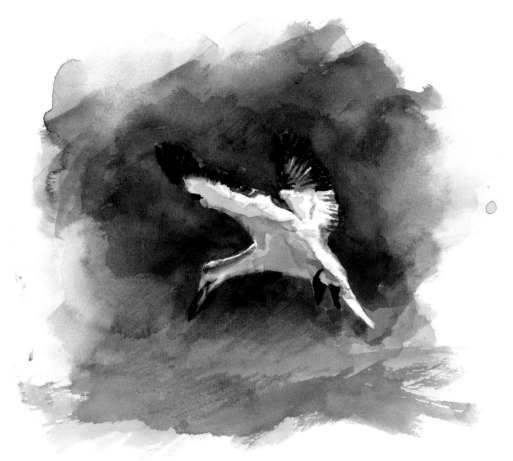

▲ One of the Tern Family

15 x 20 cm (6 x 8 in)

This painting is based on a photographic reference. I have painted broken washes of colour for the sky and the land. I have also softened the detail of the bird in order to suggest the idea of motion.

▼ Five Puffins

13 x 30 cm (5 x 12 in)

This quick sketch was based on a photograph. For compositional reasons, an alteration in the placing of the birds was necessary. A feeling of spontaneity can be caught in watercolour by excluding detail.

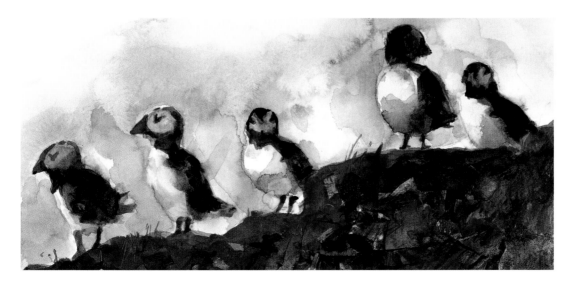

Beach discoveries

You might not immediately think of a beach as a good source of subject matter for the close-up watercolourist but, on examination, there are many interesting subjects. On sandy shores, for example, small crabs and starfish are often a common sight, whereas on rocky shores, limpets, barnacles and dog whelks may be found. Their patterns, colours and shapes may be of interest to the artist. Turn over a boulder when the tide goes out and you may even find a scallop, an anemone or a sea slug – they all make very good sketchbook material.

Further back from the sea, many species of plant life can be discovered, including sea holly and flowering plants such as sea stock and sea aster. On some cliffs, you may even come across fossilized forms of plant and animal life which lived millions of years ago.

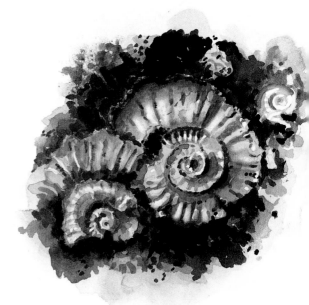

▲ *Fossilized sea shells can be found in the most surprising places; I have even found one exposed on a garden wall. On some coastal cliffs, ammonites like these are common finds. A close study of them could form the basis of an interesting little watercolour.*

▼ *Seaweeds can be a fascinating study and can even become the inspiration for some quite delicate imagery. A compilation of various types of seaweed could be beautiful as a watercolour.*

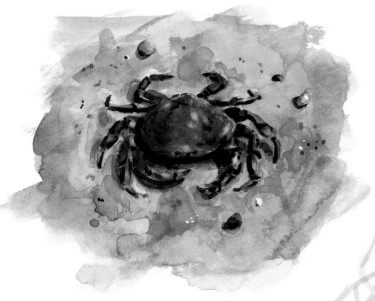

▲ *Crabs, dead and alive, are plentiful on some beaches. I have modified the colour of this one from ochre/green to red so that it contrasts with the sand.*

Creating a painting

Beach finds can become the subject for many different types of paintings. Studies of seashells made on a slightly larger scale and then suitably annotated and grouped together could make fascinating watercolours. Another possibility is to create a watercolour of a single shell with an interesting shape or form, which is then enlarged perhaps 20 or 30 times life size (a dog whelk comes to mind). Such a painting could reveal its 'architectural' character and delicate colouring.

If the seashore brings out the beachcomber in you, why not collect some items washed in by the tide? Bottles, mossy driftwood or even tin cans with foreign lettering can all provide good material for an intriguing still life.

▶ *Molluscs, such as this limpet, can often be found in colonies on coastal rocks. Their colours can range widely from pale grey through to yellows, reds and browns.*

▼ **Beach Still Life**
24 x 30 cm (9¹/₂ x 12 in)
Items that may be picked up on some beaches can be the subject for a still life. Rather than painting them on the beach why not take them home and paint them lit by an angle-poise lamp?

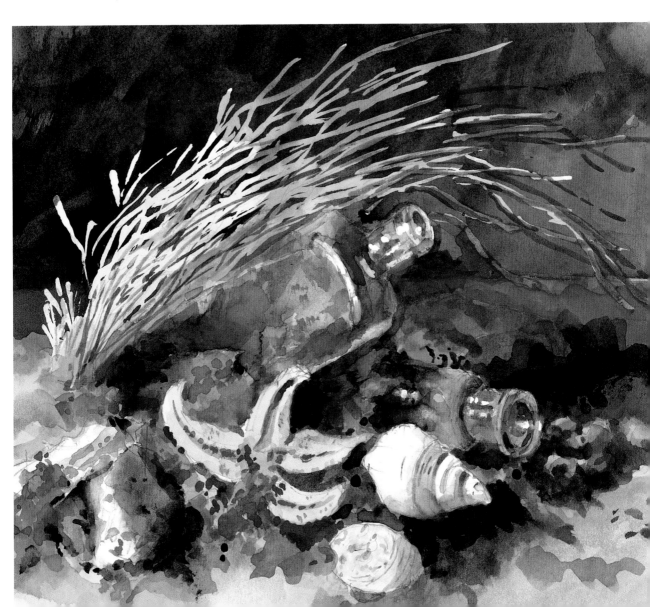

Boats and moorings

Why not take your sketchbook down by the harbour or on to the beach to get some interesting studies of both fishing and pleasure boats? Many fishermen pull their boats up on the beach, enabling you to walk around the subject and select an interesting angle. Additionally, they may be dealing with their new catch and you could include them in your sketch to make it more interesting. At the harbour mouth, you may be able to spot some boats entering or leaving. Try your hand at making quick sketches of a boat. You may be able to do a speedy drawing and add some colour at a later stage.

Drawing boats

Much the same rules apply to drawing boats as to drawing anything else. Most inaccuracies are usually the result of faulty observation or even of non-observation. It is always tempting to draw what you think you see rather than what you actually do see. Before starting to draw, make a few measurements with a pencil held up at arm's length. In this way, you can determine, just as you would with a ruler, the relative widths and depths of the

▲ **Leaving Harbour**
15 x 20 cm (6 x 8 in)
Using low tone and low-intensity colours has created a sombre late-evening effect. Lighter and brighter colours would have produced a more optimistic mood.

subject. Just a few marks will help you to make an accurate start. Use your pencil to assess the angles of diagonal elements. Basic drawing involves spaces, dimensions and angles. If you can see these and measure them, you are well on the way.

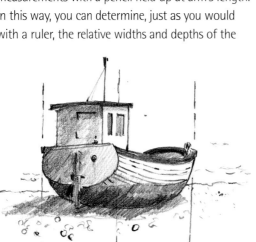

▲ *Seen from an oblique angle, the stern width of a boat may appear as wide or even wider than its side. It is tempting to draw the side longer just because the sides of boats are normally longer than the stern. If you make measurements, this kind of mistake cannot happen.*

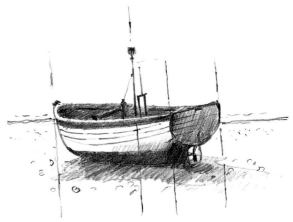

▲ *On the beach, a boat may be tilted at an angle. Try holding your pencil vertically in front of you and observe how the upright elements in your subject are leaning to the left or the right. A series of tilted parallel lines, as shown above, will help you achieve a consistent result.*

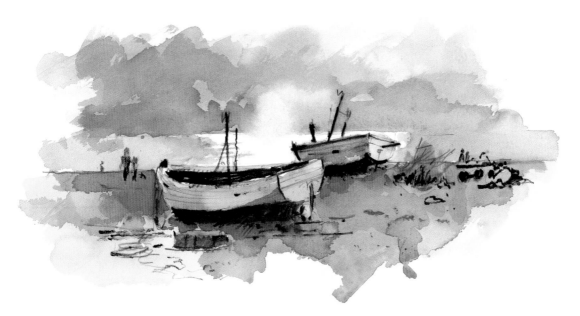

▲ *This sketch catches a rather bleak early morning scene with the boats drawn up beyond the tide. I used carbon pencil for the drawing with unevenly applied watercolour for the beach and sky.*

▼ *Moving in close, you can record details of rigging, deck housing and fishing gear. Fit separate sketches together to form a complete painting. The whole can be greater than the sum of its parts.*

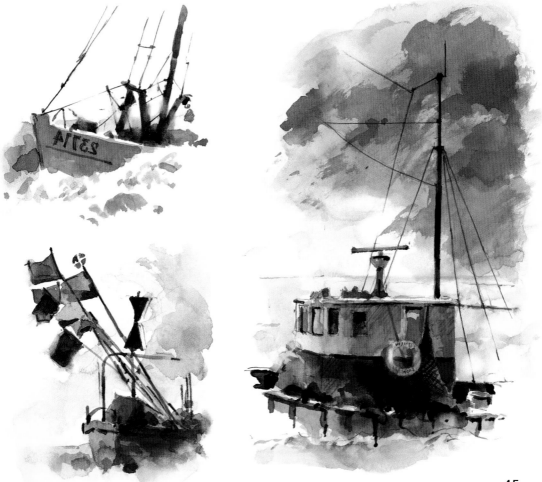

DEMONSTRATION: Fishing boat

On some beaches it is possible to find boats similar to this one pulled up on the beach and appearing to defy gravity. Such subjects can be interesting to paint either on site or at home, using photography for reference. If you do use your camera, avoid very low or awkward angles which can lead to distortions. A painting based on a distorted photograph can look quite peculiar.

1 *The nature of the drawing will determine the character of the painting. A loose drawing made with a very soft pencil could result in a painting that has very 'sketchy' appearance. In this case the drawing is detailed, making use of a sharp 3B pencil.*

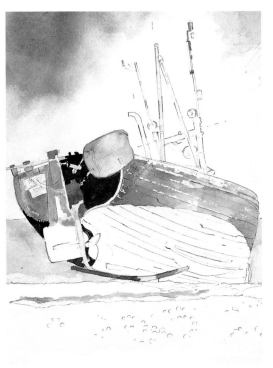

2 *On the side of the hull I brushed in the palest of washes of Yellow Ochre. Then before painting in the blue for the upper part I used masking fluid to convey the effect of worn and chipped paint. The blue I used was a mixture of Coeruleum and French Ultramarine. Before painting the foreground I used some masking fluid to suggest highlights on some pebbles.*

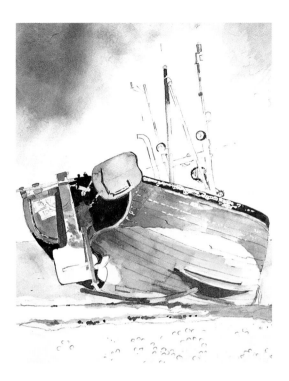

Focus on details

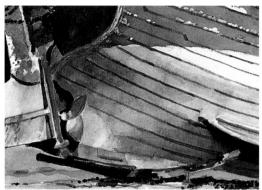

▲ *The masking fluid was removed revealing the Yellow Ochre painted beneath. Here and there, more of the same colour was added to create an irregular effect.*

3 *I mixed a warm brown for the underside of the hull using Cadmium Red, French Ultramarine and Yellow Ochre. I applied the colour in overlayed washes for an uneven effect. Other dark parts were painted in Payne's Grey and a mixture of Monestial Blue and Payne's Grey.*

▶ **On the Beach**
29 x 22 cm (11¹/₂ x 8¹/₂ in)
This last stage involved the building up of detail and colours as before on the boat. For the beach I used Cadmium Red, Yellow Ochre and a little Payne's Grey and, finally, for the sea I used mixes of Monestial Blue, French Ultramarine and a little Payne's Grey.

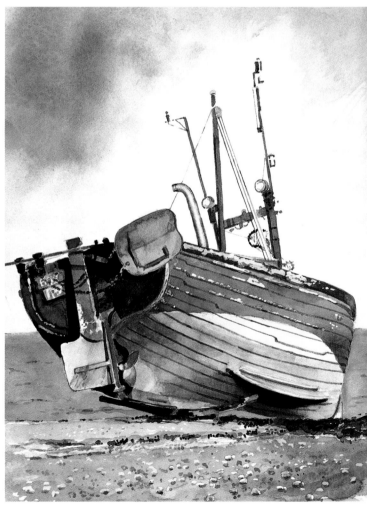

47

Children at play

Making sand castles, jumping in the waves and exploring rock pools – all children on holiday love doing these things on the beach. While they are totally preoccupied, they can also make a marvellous subject for you to sketch. On the beach, surprisingly, children can often remain relatively still for quite long periods, and these are the times when you might be able to make a quick study of them.

Making a quick sketch

Wait until your subject is not running about but playing in the sand perhaps. Aim to make the most general of drawings, defining no more than areas of tone. See whether this might be done in no more than 30 seconds. By this time (if my own children are any guide) the whole set-up will have changed and your subject will have run off. You

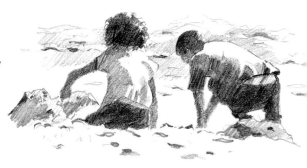

▲ When drawing areas of tone, keep the pencil marks moving in the same direction (see the waves and the girl's shirt). This will help to give the drawing a structure.

will, however, have something to work on. From memory, at this stage, you could block in areas of colour using watercolour pencils, pastel pencils or even some gouache. Sometimes little sketches like these can have a vitality which is lacking in more carefully crafted studies.

▼ For this pencil drawing I used a 3B pencil on smooth cartridge paper. With this pencil, some fine detail is obtainable with good, rich blacks.

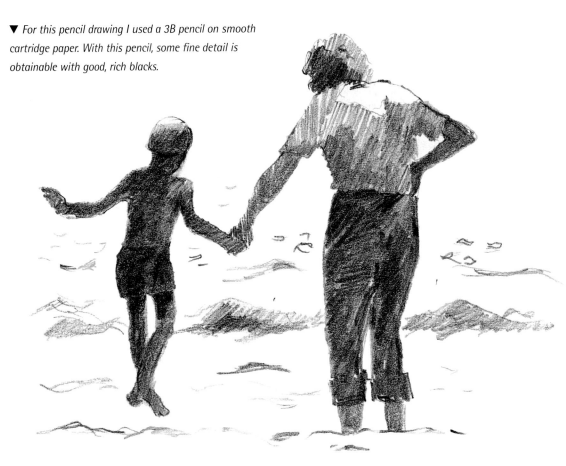

Developing your ideas

Back at home or in the studio you may well find that your sketches do not have sufficient detail to create a finished watercolour. Hopefully, you may have taken one or two photographs to give you some help. From sketches and photographic reference, it may be possible for you to make a reasonable-looking watercolour.

The important thing is not to be too tight in your painting but to allow the colours to flow. Use plenty of water and build up the dark tones, overlaying one colour with another. Many watercolourists fail because of tonal problems. Make sure that your finished result shows plenty of contrast and sparkle.

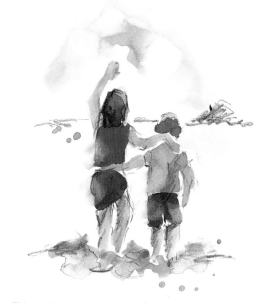

▲ *This small study makes use of gouache paint and 6B pencil. This was my first idea which looked rather static.*

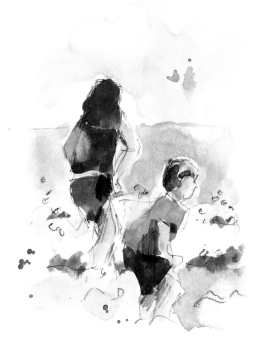

▲ *This second possibility seemed more lively. You can see how gouache will dilute just like watercolour but will allow the creation of really dark tones.*

▶ **Jumping the Waves**
22 x 13 cm (8¹/₂ x 5¹/₂ in)
Here is a more carefully finished painting in watercolour. I have avoided detail and deliberately kept the painting loose to create a sense of movement.

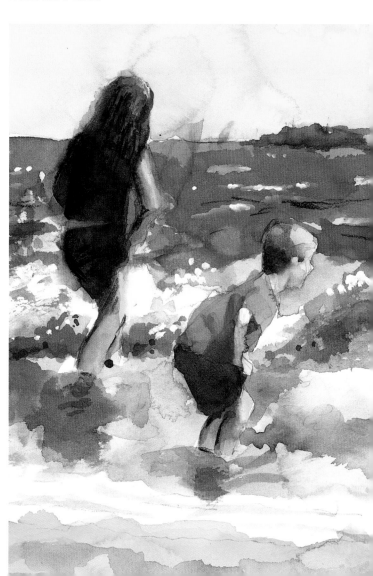

People at work, rest and play

People on beaches or at the harbour can offer innumerable opportunities for the watercolourist. On the waterfront, fishermen mending nets or maintaining their boats can be the source of many interesting visual possibilities. What could be better than to set your figures against a background of sea, sky, masts, rigging, jetties and seagulls? Alternatively, yachtsmen in their dinghies leaving the harbour can be good material for dramatic paintings, especially in blustery conditions. Other useful places are beach cafés and restaurants where you can make successful studies of people when they are most accessible and interesting. On piers and promenades, too, holidaymakers can be encountered – reading, sleeping or just sitting. You may be familiar with Seurat's marvellous studies of people on the bank of the River Seine. Many of these little pieces, sometimes painted on cigar box lids or drawn with conté crayon, show just what is possible.

Painting people

The first thing to remember when you are painting people, whatever they are doing, is that you are not painting a portrait. There is therefore no need to paint an excessive amount of detail.

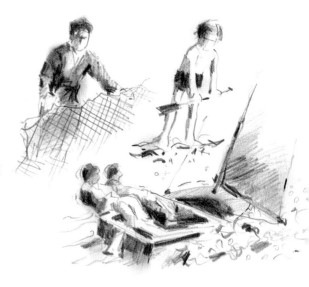

▲ *These random sketches suggest ideas for close-up subjects. In your own studies, do not get involved in too much detail but try to catch the essence of the subject. You may never translate them into paintings but they will remain a useful record for the future.*

▼ Beach Café

18 x 48 cm (7 x 19 in)
You can almost guess what the two people in the foreground are saying. They were painted first, then the background figures were added from other sources.

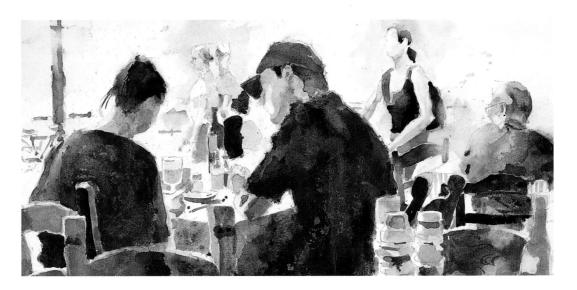

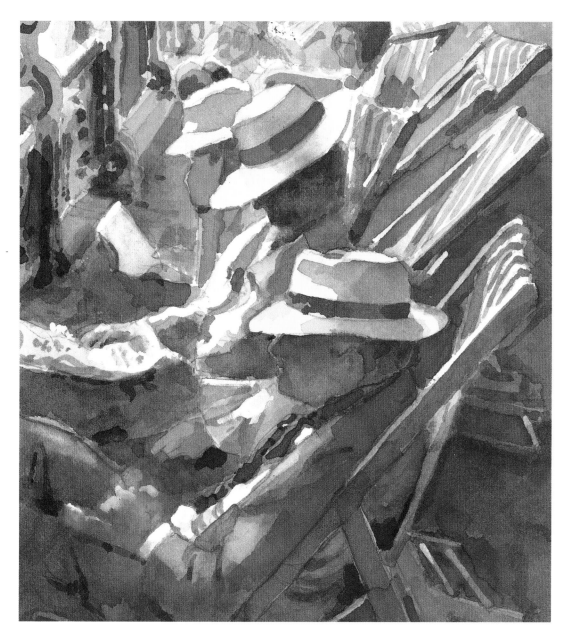

Do not worry about facial features or elaborate details of dress or clothing. Concentrate, if you can, more on the posture or attitude of the subject. The way that people sit or stand can often convey a lot about their emotional or mental state.

Angle of view

For more considered figure studies, it is probably better to place yourself where you are viewing your subject from a three-quarter rear angle. This is especially the case in cafés or similar places. This way

▲ **On the Pier**
24 x 17 cm (9¹/₂ x 6¹/₂ in)
Strong, low light often makes for an interesting picture. The hats, shirts, newspaper and deckchairs all catching the sunlight make a fascinating composition and help to give a sense of recession.

the subject is less likely to be aware of your presence, and if you can also work against the light so that the figures are in partial silhouette this will help you to simplify your drawing and eliminate detail.

Breakwaters and piers

It is sometimes possible to stand in front of a perfect subject for a watercolour and not even realize it. This can be the case with breakwaters which are not in themselves pretty or picturesque. Nevertheless, there is a certain romance about them, even when they are rotten and crumbling, having lost their battle against the sea. Indeed, perhaps it is this quality that makes them such interesting subjects for our paintings.

Like breakwaters, disused jetties and piers can also make good subject matter although it sometimes take a huge leap of the imagination to turn these heavy and ugly structures into an interesting watercolour.

Creating a mood

Often, quite mundane outdoor subjects can be made to look poetic, mysterious or even visionary just by setting them in certain dramatic conditions or by creating an unusual quality of light. The ugly wooden pier (shown opposite) is a good example. Set against an unusually coloured sky, a misty sun shines through a thin veil of cloud. It is becoming dark and thick clouds are threatening rain. The beginning of a mist partly obscures the structure.

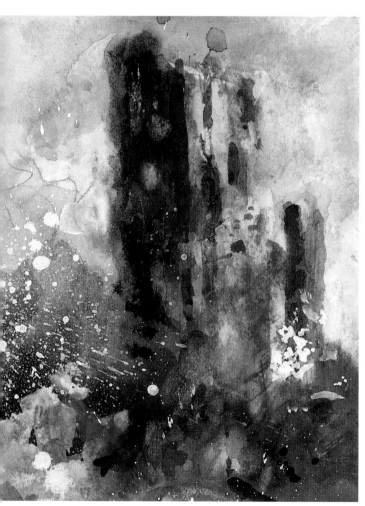

▲ Breakwater Close Up

14 x 10 cm (5¹/₂ x 4 in)

To suggest the moss on this groyne, I used Prussian Blue and Lemon Yellow, overlaying darker mixtures of the same colours. While the paint was wet, I rubbed some of it out with a cotton bud and scratched it with a fingernail!

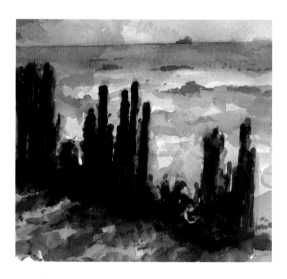

▲ A Crumbling Breakwater

15 x 16 cm (6 x 6¹/₄ in)

This was hastily painted before a period of rain. Some alterations to the colour and tones of the subject were made. I used Payne's Grey and Indigo for the groynes with overpainting of a dilute Cadmium Red. The other colours used were French Ultramarine, Monestial Blue and Yellow Ochre.

Bad weather techniques

Creating a stormy sky can be achieved by overlaying successive washes of colour painted wet-on-dry. Each wet wash can be manipulated with either wet cotton wool, cotton buds or, if you wish to suggest rain, with a fine comb lightly scratched over the top. It is always best to begin your washes with pale, dilute colours and to finish with darker, concentrated mixes.

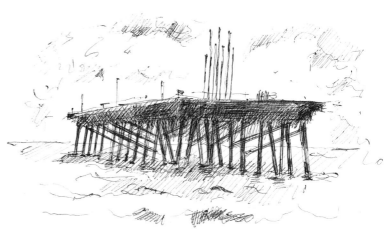

▼ Disused Pier

13 x 23 cm (5 x 9 in)

The sky was painted in washes of colour mixed from Indigo, Yellow Ochre, Cadmium Yellow, Aureolin and Cadmium Red. The sun was wiped out with damp cotton wool using a paper mask – simply a piece of cartridge paper with a small hole cut in it.

▲ *This sketch of a disused pier is a quick representation made with a ballpoint pen – a better tool for drawing than some people might think.*

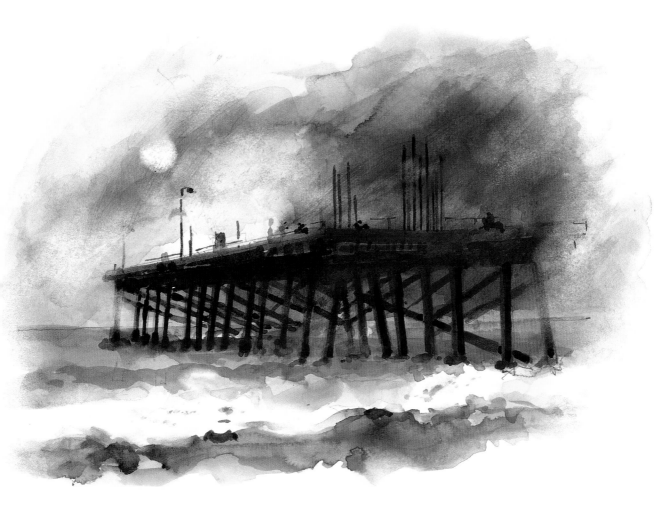

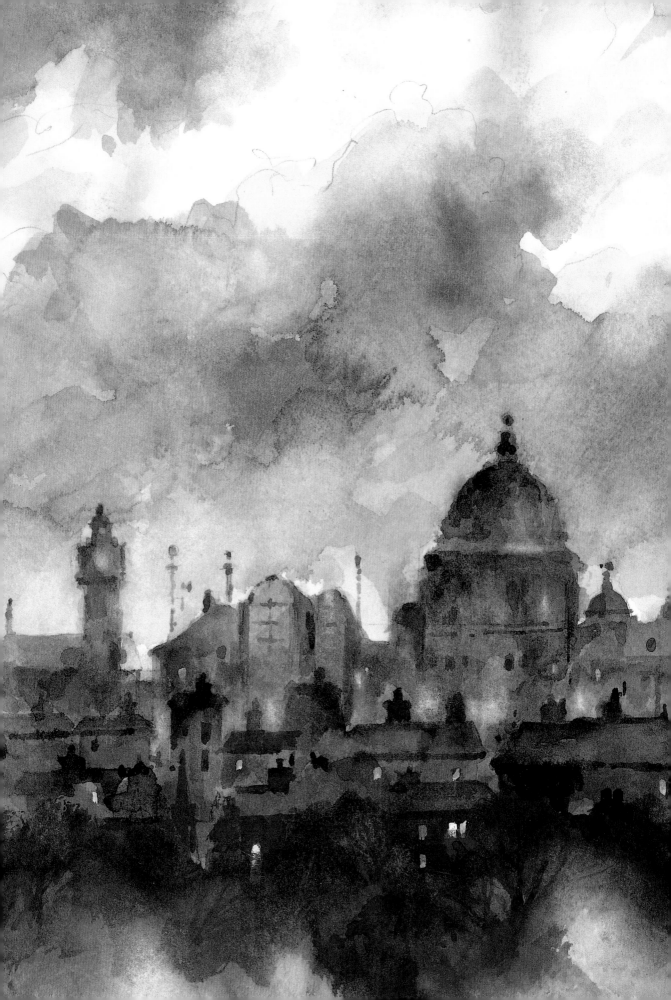

In the Town

A city or town might not be considered the best of locations for interesting close-up watercolour subjects. Many painters are only too happy to turn their attention elsewhere for subject matter. Yet fascinating subjects may be found in city streets and buildings, especially when viewed close at hand: doors, windows, chimneys, signs, statues and fountains. Such architectural features can be wonderful to draw and paint. Moving in even closer, it may be possible to sketch or draw fascinating details, especially in churches and cathedrals. The act of recording them, even in rough unfinished terms, can be deeply satisfying.

As an alternative, an area of wasteland in a town can offer some splendid subjects, especially derelict industrial sites. Consider old signs, lamps and machinery, broken windows or crumbling brickwork. If you use your artist's eye, corrosion and neglect can be made the subject matter of beautiful paintings. The gracious or the grimy – the choice is yours!

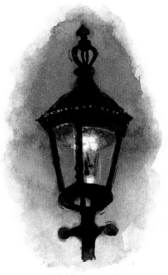

◀ **London Skyline**
36 x 33 cm (14 x 13 in)

Painting doors and entrances

We often walk past doorways and entrances without noticing their potential as suitable subjects for sketching or painting. A door and its immediate surroundings that may be quite unattractive can still form the basis of a very interesting or even a beautiful watercolour. Old and grimy features with peeling paintwork (see page 64) and broken glass often make wonderful subjects. It can be all too easy to look at entrances with the eye of a building inspector rather than an artist. The best subjects can be found by keeping an open mind and a sharp lookout.

An alternative possibility

Well maintained, newly painted doors and entrances can also make interesting paintings; the reader's own possibly! If a door faces the sun, make some studies of it at different times of the day: in the early morning, at midday, in the late afternoon and even at night, illuminated by artificial light. Small studies could be mounted up together showing the door in changing lighting conditions. Try painting your door partially open to reveal an inside detail, a hall table maybe. Move in closer and paint the lower part of your door with milk bottles on the step outside. Think of other ideas; use your imagination and ingenuity to make the entrance to your house really interesting. If all else fails, surround your door with potted flowers. They provide colour and interest, making most entrances a special delight.

◀ **Suburban Door**
15 x 10 cm (6 x 4 in)
A line and wash drawing can be easily made using a minimum of materials. For this drawing I used a medium-width nib in an old-fashioned dip pen with some waterproof ink. When dry, colour washes of watercolour were laid over the top.

▶ **Chania Steps**
43 x 20 cm (17 x 11½ in)
Watercolours painted in sunny climes will usually encourage the use of brighter colours and stronger contrasts. The doorway at the top, half hidden by flowering plants, makes an appealing subject.

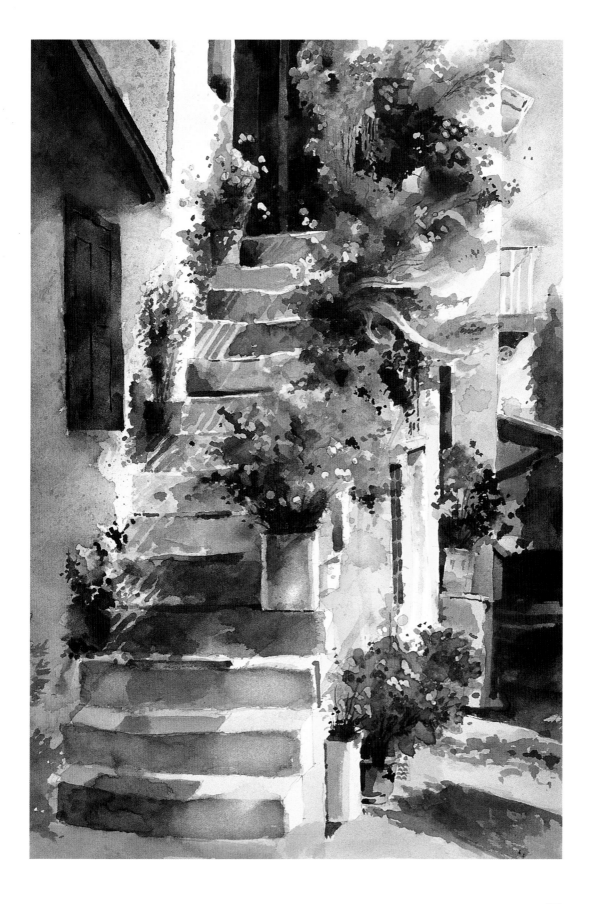

Different lighting conditions

When painting a doorway in sunlight, try creating strong variations of tone and colour: bright colours in sunlight and more muted and darker ones in shadow. A red colour in the light can become a low-toned brown in the shade. A sunlit green becomes, in shadow, a low-toned blue green. Mix some red with this colour to lower its intensity, i.e. make it duller.

Sunless conditions

All this is fine for sunlight but, you may ask, what if there is no sun? Effective work can be based also on a wide range of subjects that are painted on cloudy days. Indeed, a doorway which is painted in misty conditions could, in certain circumstances, become the basis of a really splendid watercolour.

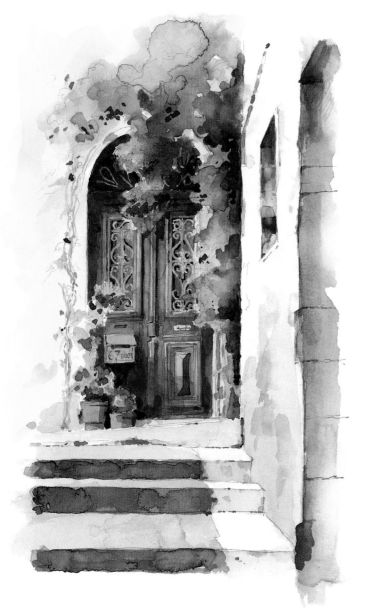

▲ *I made some rough experiments with laying down masking fluid on top of a light wash before I started to work on the finished painting of the doorway (left).*

◀ **The Entrance to No. 67**
25.5 x 14 cm (10 x 5¹/₂ in)
Sunlight picks out the detailing on this door which is painted freely to avoid an overly rigid look. Further layers of paint were added before removing the dried masking fluid.

A doorway in flat daylight might well be a fully paintable proposition if the parts that make up the scene have strong tonal contrasts, such as pale brickwork set against a low-toned door; dark foliage against white paintwork; or brightly coloured flowers set against a low-toned step or pavement. Subjects with these contrasts of colour and tone can often work quite effectively.

Experimental method

During the course of painting doorway subjects, or indeed any subject, always be prepared to make tests on a separate piece of paper to see how an effect might be obtained. For example, you might want to find out the best colours to use to suggest sunlight falling across a brick wall or how a complicated feature, such as decorative elements on a door, might be suggested. By making a habit of experimenting with various methods of working, you will be developing your ability as a watercolourist. Keep your experiments together in a folder and consult them for future use and reference.

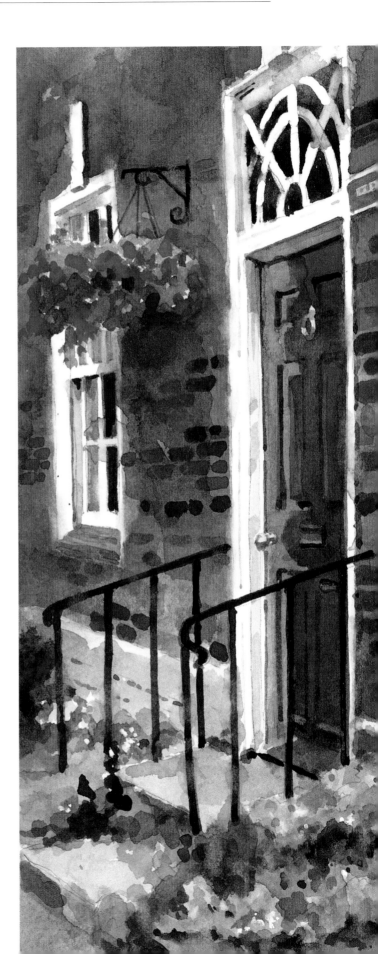

▶ Blue Door

27 x 13 cm (10³/₄ x 5 in)

You can create a realistic yet lively watercolour even in sunless conditions by exaggerating the differences between the light and dark areas of the painting. Here I lowered the value of the brick wall and, because the paintwork was white in this subject, I left it mainly unpainted, but added just a pale wash over the top. To liven up the space a little, I added unmixed gouache colours over the foliage to suggest flowers which were missing unfortunately at the time of painting.

Painting windows

It is curious that one sees so few watercolours of windows. Perhaps this is because they are perceived by many artists as having little visual appeal. However, this is certainly not the case. Windows can make wonderful paintings.

Like many other architectural features, a window will often look better if it is drawn and painted from an oblique angle, thereby avoiding an excess of horizontal and vertical lines. Also, if the window is recessed in the wall this can be shown easily. Painted from the front, a window can sometimes (but not always!) look flat and unexciting. It may be that the window has an unusual shape or has an interesting protective grille. Possibly it has a window box with some luxuriant blossom, in which case viewing from the front might be the best option.

From light into dark

A softly lit room at night, when viewed from the outside, can be fascinating, rather like a stage set where a drama is just about to begin. If you want to try a subject like this, then taking a photograph and using it as the basis for your painting will be an option, but it is possible to work from sketches made in the half-light.

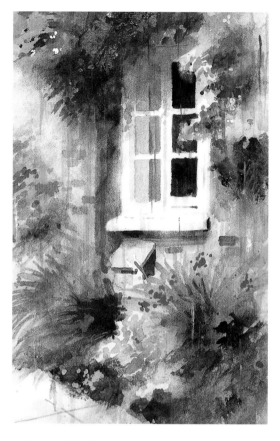

▲ **Pleasant Outlook**

38 x 28 cm (15 x 11 in)

A window surrounded by dense foliage will usually make an attractive watercolour.

Paint low-toned washes of colour and then show any external details almost in silhouette form. Moving in close where the window acts as a frame can overcome the need to include outside features such as brickwork and plants. But further back the window can become the focal point of a half-hidden mysterious exterior.

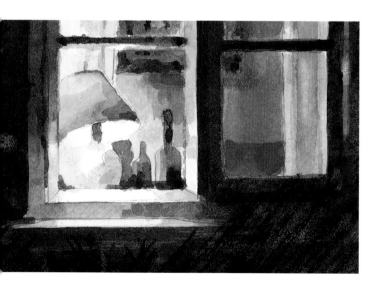

◀ **Window at Night**

14 x 20 cm (5¹/₂ x 8 in)

The inside of the room was painted in pale colours. To make the outside wall look sufficiently dark I hatched black conté crayon over previously laid dense watercolour.

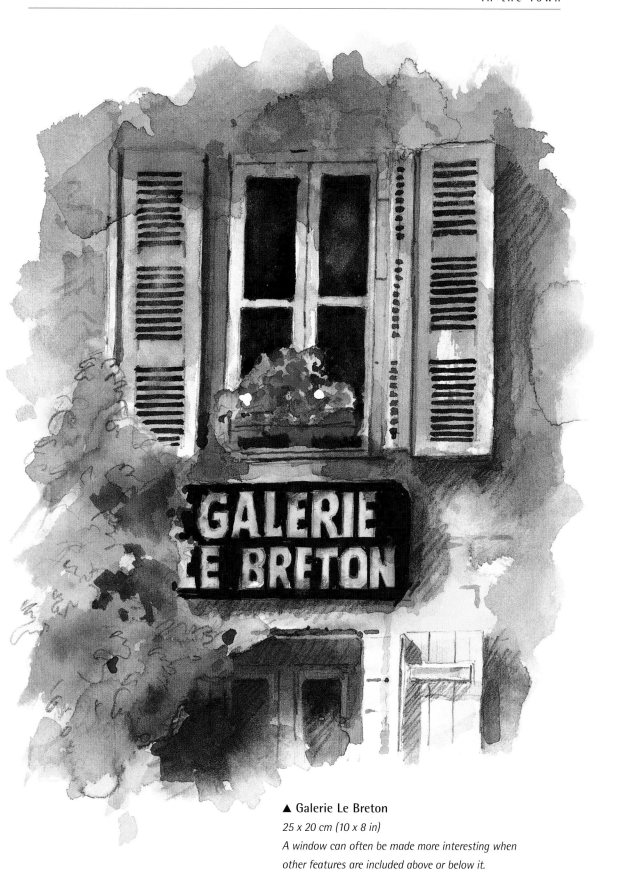

▲ Galerie Le Breton

25 x 20 cm (10 x 8 in)

A window can often be made more interesting when
other features are included above or below it.

DEMONSTRATION: Window with foliage

At the far end of a town garden this somewhat neglected outhouse had a year or so earlier been reglazed using an old schoolhouse window. Already Virginia creeper was beginning to obscure it from the top, and before weeds completed the job from the bottom I decided to interpret it as a watercolour. To help create an atmosphere of neglect, I used a limited range of colours.

1 *I began by making a fairly careful drawing of the subject, even indicating some detail in the foliage which was growing over the window panes. The first washes were mixed from Indigo, French Ultramarine, Cadmium Yellow Deep and Yellow Ochre.*

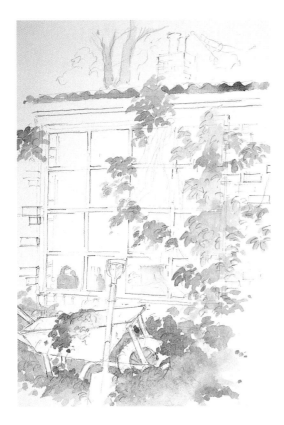

2 *Masking fluid was laid down for the stems of the vine and over this I painted a pale yellow/brown wash over the window panes. For the wheelbarrow I used Payne's Grey and Cadmium Red; for the window and outside wall Yellow Ochre, Cadmium Red and French Ultramarine.*

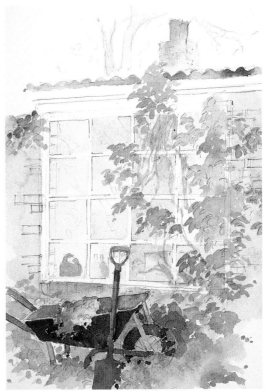

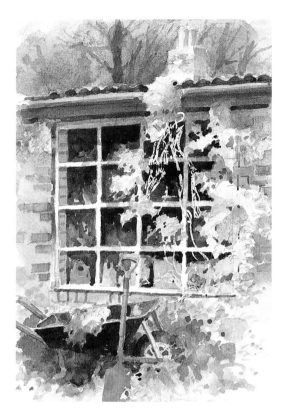

3 *The window panes were built up with Payne's Grey, Indigo and Yellow Ochre 'reserving' spaces which define the items inside the window. For the chimney stack, I used a pale wash of Cadmium Red with just a little French Ultramarine. I then used more concentrated mixtures to lower tonal values, brushing some French Ultramarine at the top of the window to suggest shade.*

▶ **Outhouse Window**

30 x 25 cm (12 x 10¹/₂ in)

I gently rubbed off the masking fluid for the stems and painted over the top browns with yellow/brown mixed from Cadmium Red, Yellow Ochre and French Ultramarine. Some final detailing of the leaves with a pen provided the finishing touch.

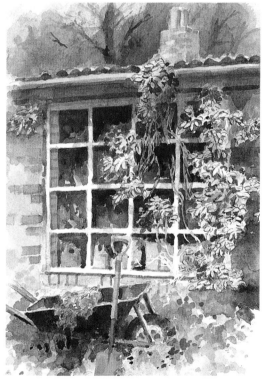

Textures and brickwork

Both man-made and natural materials can make interesting studies, sometimes in their original form but also when they have interacted with the weather. For instance, metal will rust, wood will rot and paint will peel. Even bricks will eventually crumble away. Many materials like these can become the object of study for the watercolourist. Without using tricks or special effects, but employing your powers of close observation, it can be possible to match their visual qualities in paint. Try it yourself; you will discover that it's easier than you think.

▲ Rust will lift the surface of metal in flakes. This three-dimensional quality can be suggested by creating a pattern of tiny shadows over the area.

▲ Observe the surface carefully. This wood also has a three-dimensional characteristic. Remember that paint becomes very pale and washed out as it becomes older.

Cadmium Yellow Deep

French Ultramarine

Cadmium Scarlet

Payne's Grey

Yellow Ochre

Monestial Blue

Payne's Grey

Yellow Ochre

Cadmium Orange

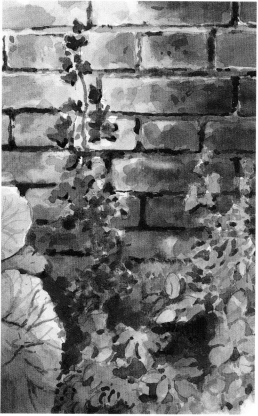

▲ When you are painting wood grain, make sure that the colours used are not too intense (bright). Also avoid hard edges by softening the edges of the grain with cotton wool or blotting paper while wet.

▲ Old brickwork in close-up can be wonderful to paint, especially when it is affected by damp and decay.

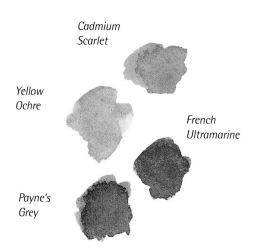

Cadmium
Scarlet

Yellow
Ochre

French
Ultramarine

Payne's
Grey

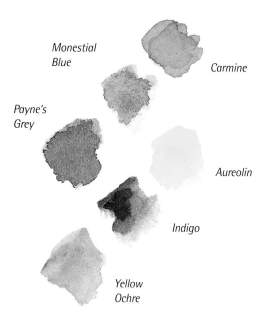

Monestial
Blue

Carmine

Payne's
Grey

Aureolin

Indigo

Yellow
Ochre

Street lighting

Possibly one of the last things that might be thought of as a watercolour subject in the city is street lighting. Yet the means by which we illuminate our streets can reveal some interesting features. In many places, in the older parts of a town, early twentieth-century lamps and lamp standards may still be found. In odd corners, sometimes in alleys or on footpaths, it is still possible to see a solitary elderly light feebly illuminating a dark corner.

Numerous public buildings are now lit by modern lighting methods which can often be very interesting to draw or paint; it can certainly be worthwhile to keep an eye open for these.

▼ **Street Corner Lamp**
9 x 20 cm (7¹/₂ x 11¹/₂ in)
As in this painting, you can create the effect of strong light by using powerful contrasts of pale and dark tones.

Creating atmosphere

Sunlight can be fine for painting, but in the case of street lighting other weather conditions might be better. If painting in the daytime or at dusk, you can obtain interesting effects in misty or even rainy conditions. It is possible to paint

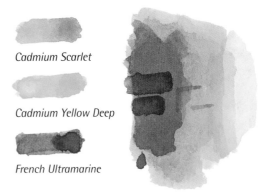

Cadmium Scarlet

Cadmium Yellow Deep

French Ultramarine

▲ *Yellow/orange brickwork in shadow becomes almost black. Always avoid Payne's Grey for the shadow areas.*

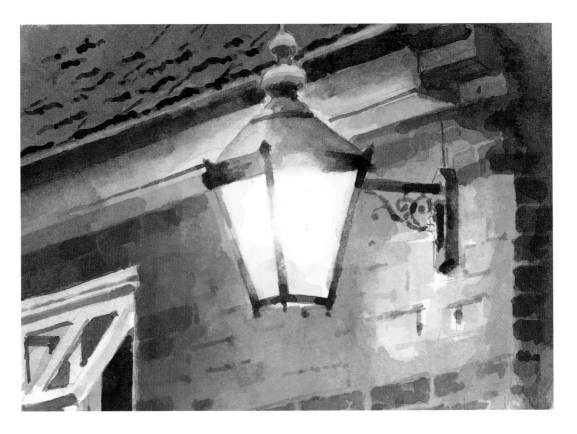

street lights against a cloudy sky or even towards a barely seen, partially obscured sun. Turner was a great exponent of painting in these conditions, using muted and diffused light to create an air of melancholy and stillness.

The colours you choose when painting will have a pronounced effect on the mood of your finished work. Cool, muted and blue-green colours will produce an air of quietness and peace. Heavily neutralizing these colours, by adding some red or orange to the mix, can create slate-like or steely colours which, if used in the right way, can be useful for industrial and run-down subjects. Alternatively, more modern housing in suburbia might need yellow and orange colours to create a more optimistic quality, a feeling of warmth and cheerfulness.

▶ **Street Light with Seagull**
30.5 x 10 cm (12 x 4 in)
Smudged paintwork in this watercolour helps to suggest the sense of dereliction and decay. The seagull provides a stark contrast.

Yellow Ochre

French Ultramarine

Payne's Grey

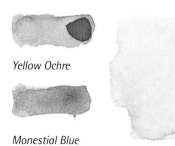

Yellow Ochre

Monestial Blue

▲ *These three colours in alternative mixes and concentrations can make beautiful greys.*

▲ *These two colours in a dilute mix will make a lovely delicate yellow/grey.*

City parks

Many town and city parks offer a refuge from the rat race or at least an opportunity to get away from the traffic. For the urban watercolourist, they provide an opportunity to paint subjects other than streets, buildings and pavements. What is more, in a park many features may be found that can be painted in close-up, such as fountains, gates, statues, boats, seats, flowers and trees. All of these can make wonderful subjects.

Working quickly

It often happens that a watercolour painted in haste will look better than one produced slowly and deliberately. The act of quickly laying down paint can result in a painting which, although perhaps inaccurate, looks somehow more fresh and vibrant. Paint that is splashed down and is then overpainted before it dries off produces these exciting effects, and at a later date one wonders how they were achieved. Detail, which is suggested by the crudest of painted marks – as in foliage, for example – allows the viewer a part

▼ **Boating Lake**

13 x 14 cm (5 x 5¹/₂ in)

Masking fluid was used here to create an effect of light reflected on water. Painting into the sun, although often hard on the eyes, can lead to an interesting painting.

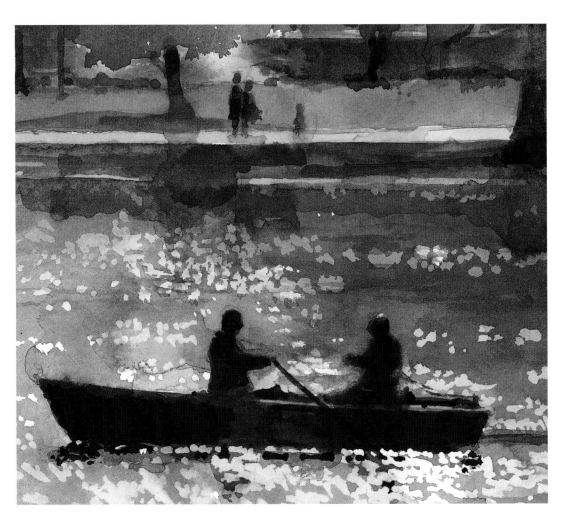

in 'reading' the painting. It is not always necessary to describe detail in a laborious fashion.

Therefore it may be useful occasionally to give oneself a time limit in painting or sketching: perhaps 90 minutes to produce a watercolour measuring 38 x 28 cm (15 x 11 in). Begin with a close-up subject in a park – something simple such as a drinking fountain with background trees or foliage. In the drawing, define only the basic shapes of the main subject with the minimum of detail. Draw any foliage as shapes. Your paint should be applied mixed with less water than you may normally use. Keep the paint flowing and work over the top of wet paint with darker colours where necessary.

▼ *This sketchbook study, which was made in a Naples park, avoids excessive detail and makes effective use of freely painted washes. It took me approximately an hour and a half to produce.*

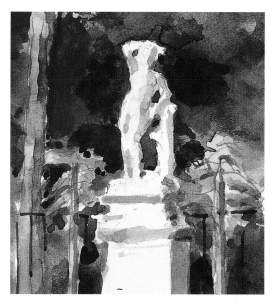

▲ Park Statue

7.5 x 6.5 cm (3 x 2¹/₂ in)
This is a very quick loosely painted study of a statue set against deep green foliage. No details are shown at all.

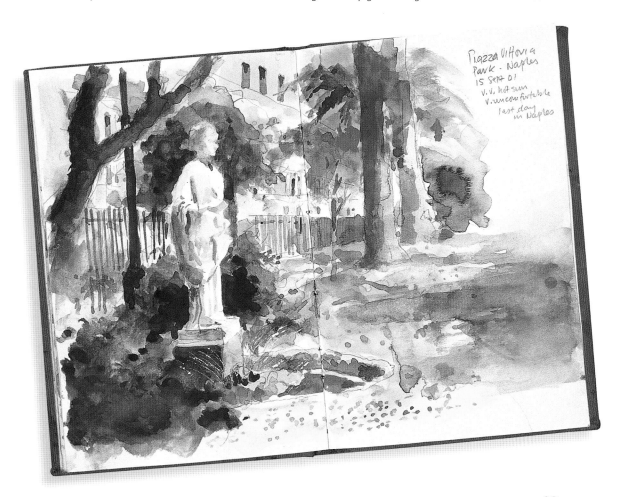

City gardens

The size of a garden and the quality of its cultivation may have nothing to do with the number of good close-up subjects it offers. A small plot in the city centre often provides more opportunities for painting than an acre of lawn in the suburbs. Nor do flowers have any bearing on the matter. There can be as many subjects to paint in a garden with few flowers as in one with plentifully stocked herbaceous borders.

▲ Garden Pond
36 x 24 cm (14 x 9¹/₂ in)
A simple subject like this one can be painted again and again. Do not be intimidated by foliage. It is often possible to describe the verdure by using a variegated wash with just the minimum of detail.

▶ The Urn
36 x 23 cm (14 x 9 in)
An overgrown garden subject painted in three colours: Yellow Ochre, French Ultramarine and Indigo.

Behind the potting shed
Look for close-up subjects in hidden places. Often cast-aside garden items overcome by grass and weeds can be splendid to paint. That unused and rusty old dustbin, which has long ceased to be a compost maker, might just be right for a close-up watercolour. A broken fence, an abandoned greenhouse or crumbling outhouse might also contain a good subject.

Hanging baskets
Even in those homes with little or no floriculture in the garden, it can still be possible to obtain an abundance of flowers by the means of a hanging basket. If you would like to paint such a subject, then your best plan would be to position it in the context of a background with some visual interest, such as a window or part of a porch. Possibly you might have a brick wall you can use as a background, but any textured surface might do. Avoid painting a hanging basket against the sky; a low-toned setting is much better.

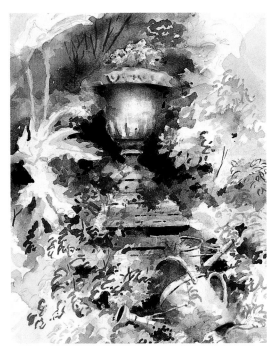

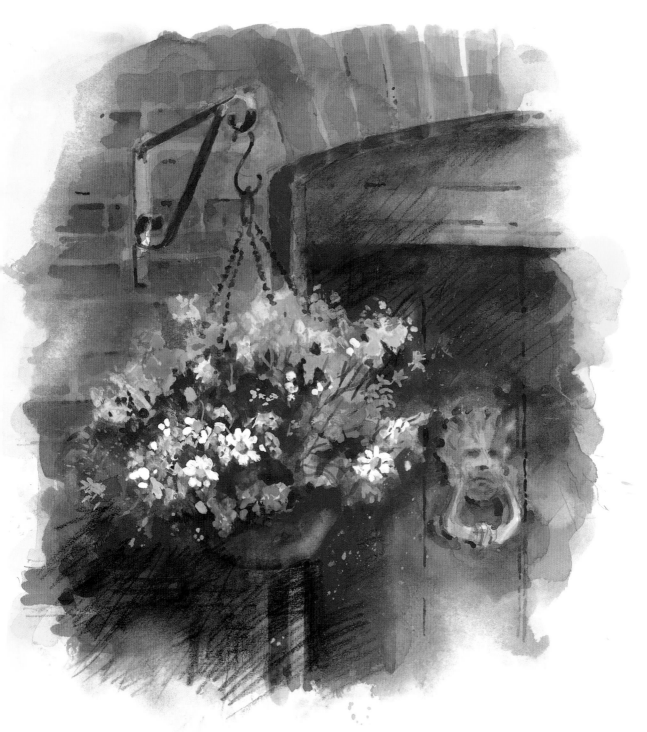

▲ Hanging Basket

28 x 23 cm (11 x 9 in)

If your display is short of blossom invent some. White gouache mixed with watercolour can often be useful for overpainting flowers where necessary.

Figures in an urban setting

Thankfully, there is no shortage of people in towns: women out shopping, business people on the train, workmen mending the road, children in the park, all employed in different activities. They can be fascinating subject matter for the sketcher, jotted down in a matter of moments, possibly just using a pencil and some splashes of watercolour. Alternatively, by working from photographs at home or in the studio, you can make more careful studies of figures using more traditional watercolour techniques.

Using a sketchbook

Sketchbook figure studies must be made quickly. Often the subject of a study will move on before the sketch has barely been started, let alone finished. Even a seated figure on a park bench may irritatingly change position at a critical point in your drawing. Employ sketching materials that can be used rapidly. If you are new to figure sketching, the obvious choice is a pencil (a 4B or 6B) but felt nibs are good, too. Use a small sketchbook, no bigger than 15 x 10 cm (6 x 4 in). If you want to use colour, add it at a later stage.

Hard and soft edges

One way to make watercolours more interesting is to vary the definition of painted areas. The edges of painted shapes will normally form with hard edges, a normal part of the painting process. But it is possible to create a soft edge

▲ *These blocked-in figures from my sketchbook are partly observed and partly made up. As you can see, they are simplified to the bare essentials.*

◀ **Station**
33 x 19 cm (13 x 7¹/₂ in)
This was painted from a photo. I like the arrangement of the figures and the sense of expectation in some and boredom in others. I have softened many outlines by rubbing the paint out when dry.

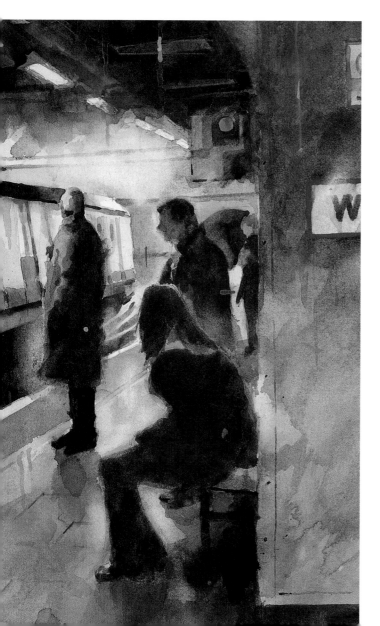

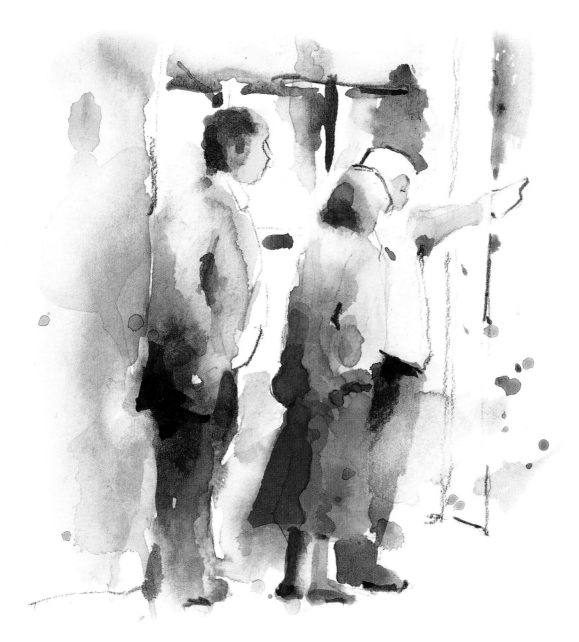

▲ **Three Tourists**

15 x 10 cm (6 x 4 in)

This was sketched with a pencil, and the colour was dabbed in later. Showing the figures' facial features in this case would be unnecessary.

by lightly adding some water to the edge of the shape while it is still wet. You can soften the edges of dry areas of paint by gently rubbing them with damp cotton wool. Hard- and soft-edged areas of paint will contribute to a much looser appearance; watercolours that have only hard edges can be solid, dull and predictable. As an experiment, paint some simple shapes and, while wet, loosen their edges with clear water.

Avoid excessive detail

Do not paint everything you see. Watercolours overloaded with detail can be tedious so paint general shapes. In figures, aim to leave out facial features. Look at your subject with half-closed eyes and then paint what you see.

People at work

One of the most rewarding figure studies to draw or paint is of somebody involved in an activity of some sort: for example, a bricklayer at work, a window cleaner or someone cleaning a doorstep. When sketching such subjects, it is not necessary to show the individual's facial features. Their body posture, shape and clothing can reveal much about their life and character – more so often than their face.

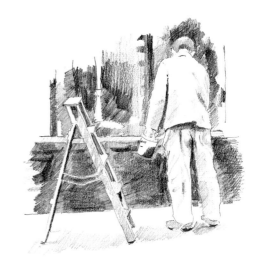

A method of working

Begin by producing a sketch with colours and tones 'blocked in' and by taking perhaps one or two photographs. Your sketch, which need not be highly finished, will give you an idea of its potential as a finished work.

▲ *A painter at work. Before embarking on a watercolour painting, it can be useful sometimes to make a simple tonal drawing of the subject.*

▼ *A further development can be to explore the possibility of an alternative composition.*

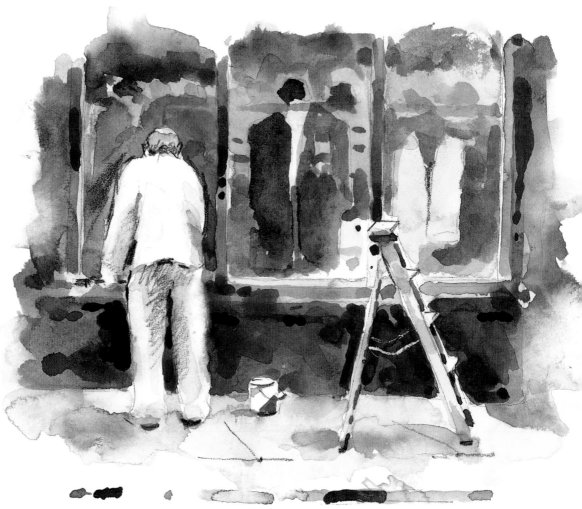

Before proceeding to the next stage, it may be a good idea to consider any alterations in composition which might be necessary. Possibly a drawing might be all that is needed. This could be more finished and could show how the detail of the subject might be treated.

▼ **Painter at Work**

27 x 27 cm (10^1/$_2$ x 10^1/$_2$ in)

The finished watercolour is based more directly on the original composition. My watercolour is fluid and loose, while the painter's brushwork is meticulous by necessity.

Using photographs

If you want to make use of photography for your finished result, remember that a watercolour should look like a painting and not a photograph. Aim to leave out any unnecessary details; reduce them to areas of tone and colour. You don't need to tell the viewer everything – leave them to do something in interpreting your watercolour. Make the paint look interesting on the paper. Flat, even washes can be a technical achievement but they can often look quite dull. Practise what might be called 'controlled careless brushwork' to escape from stark reality.

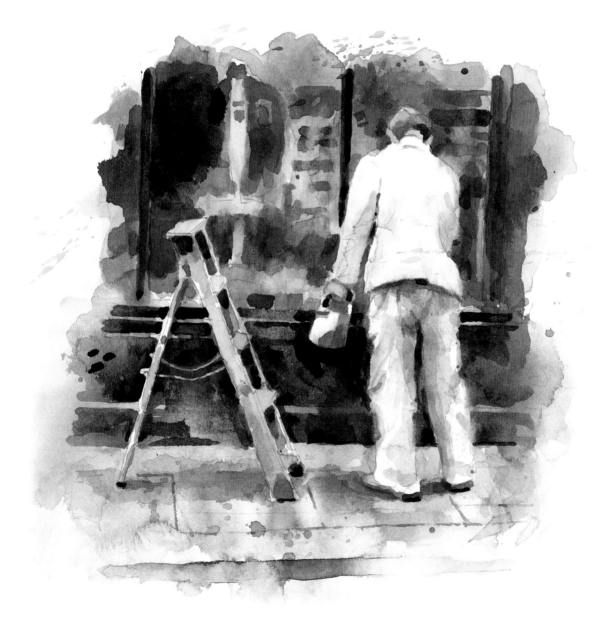

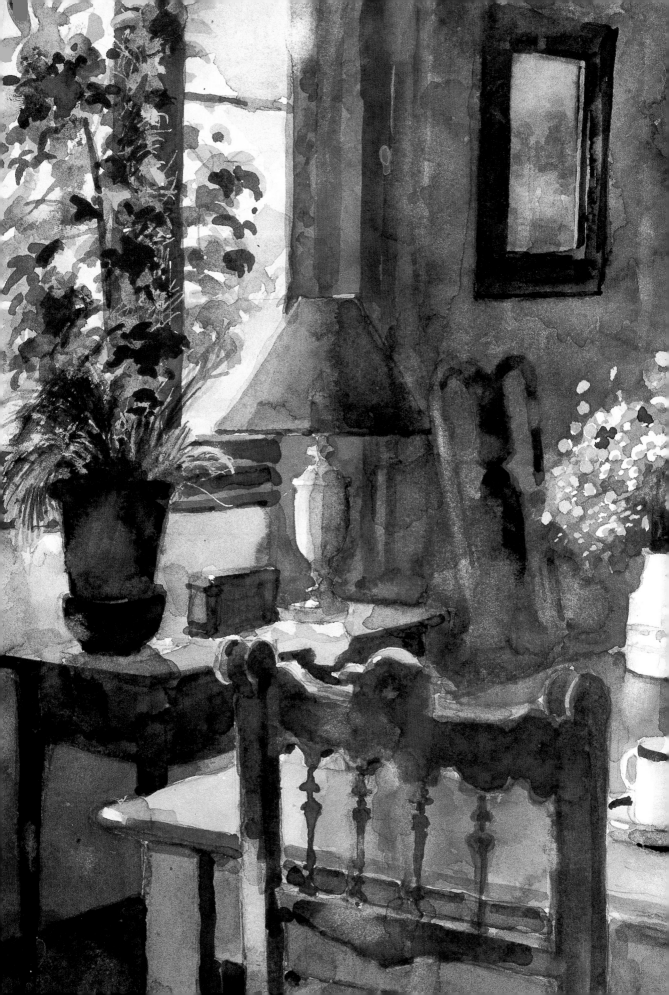

In the House

As a subject for watercolour there is no place like home. Whether you live in a mansion, a flat or a tiny cottage there will always be something worth painting there, especially for the artist who wants to work in close-up. Just consider the possibilities: doorways, windows, ledges, shelves, cupboards, tables and chairs – even sinks. Such items can be so simple to paint and yet offer such opportunities.

If you need any inspiration, look out for Vincent Van Gogh's beautiful oil paintings of domestic subjects, or see the interiors painted in watercolour by David Remfry or Howard Morgan. Moving closer still, you may want to explore the potential for some really intimate studies of ordinary domestic items, such as teapots, fruit bowls, houseplants, glassware, chinaware, mirrors and bottles. Subjects such as these can be the basis for watercolours showing the beauty and delicacy of this best of all possible mediums.

◀ **Room at The Dell**
29 x 28 cm (11¹/₂ x 11 in)

Room corners

Spaces in the home that are often passed by every day may well provide good subjects for the close-up watercolourist. Open cupboards, chests of drawers and window spaces can present you with wonderful opportunities. Even small areas of a room are suitable: the chair in a corner with a coat thrown over it; the ledge of a window with a cup and saucer and a book perhaps; or maybe an overfilled wastepaper basket. Such unpretentious subjects as these can make for delightful watercolours.

Interior light

It may be that the corner you choose for a painting is satisfactory in all respects except for its illumination. Interior subjects with no sense of light and shade can make difficult subjects to paint in watercolour. It is best if you can find something which is not far from a window to enable you to obtain good lights and darks in your painting. Failing this, you may need to provide artificial lighting of your own. Flexible localized lighting from table or anglepoise lamps is probably better than overhead lighting.

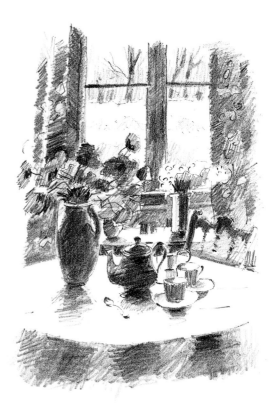

▲ *This subject is good against the light. I used a 4B pencil for this sketch, keeping its point very sharp. You will find that a craft knife is better for sharpening your pencils than a normal pencil sharpener.*

Limited colours

Interesting watercolours of interior subjects can come about by using a limited colour palette. Depending on the subject matter, a range of cool or warm colours might be used. Thus blues and blue/greens might be employed in studies where shadows predominate, or where a tranquil mood is being suggested. Conversely, colours that are more at the red/yellow end of the spectrum would help to create a feeling of warmth or

◄ **Home Computer**
20 x 20 cm (8 x 8 in)
Even a computer, that most functional of objects in your home, is worth your attention. Loose paintwork can liven up this static subject.

cordiality. Subjects that are illuminated by artificial light most certainly would come into this category. In each colour range, aim to use no more than three or four pigments. You may be surprised at what subtle effects can be achieved.

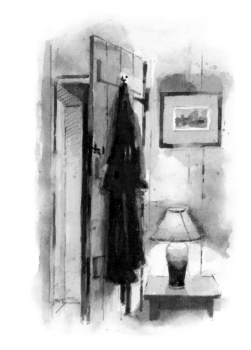

▶ Dressing Gown

25.5 x 16.5 cm (10 x 61/2 in)

Use electric lighting to illuminate a dark corner. In this case, the low angle of light makes the subject of the painting much more interesting.

▼ Unmade Bed

13 x 13 cm (5 x 5 in)

Untidiness can make the best of subjects. Quick, rough watercolour sketches like these can be good to do. They are wonderful material for your sketchbook.

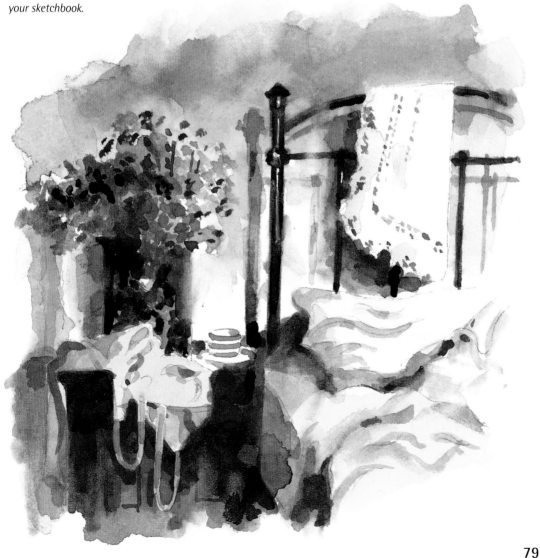

Making a painting work

A painting might begin in a number of ways. You may have an idea that has come out of nowhere or perhaps has been suggested by a painting in an exhibition. Alternatively, a newspaper or magazine cutting may provide a starting point. Or you may see one or two items in your house which suggest a good subject. Whatever the starting point, it can be useful to make some preliminary studies before embarking on a more ambitious watercolour.

Exploring the subject

A good way of beginning any painting is to make a small study no bigger than 20 cm (8 in) in any direction – smaller than this if you are working in pencil. Such studies will be of help in establishing the general composition of the picture and its overall proportion (length to breadth). Colour sketches enable you to obtain a sense of how a finished painting might look. These studies need not be too detailed, but it is important to focus on the lights and darks of the subject in addition to the colour values. Also, you may want to prepare a separate preparatory sketch of just a part of the painting to solve any problems that might occur when you come to produce the final watercolour.

Whatever the purpose of these studies, you should aim to paint quickly and loosely. If you get into the habit of working in this way, it may be that your watercolours will achieve vitality and freshness, the envy of all.

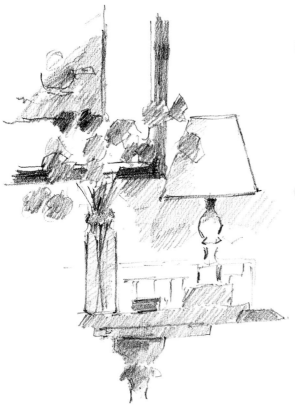

▲ Small pencil sketches like this one can be the first part of the painting process.

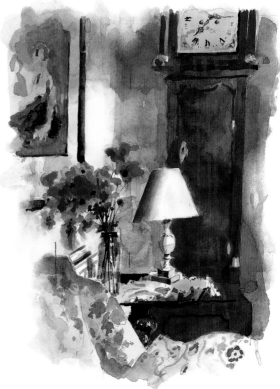

▲ A loose painting to test out an idea. The composition is poor and the lamp is just asking to be lit.

▶ *A separate study at night suggested an alternative approach to the same subject. The lamp, now lit, has become the focus of attention.*

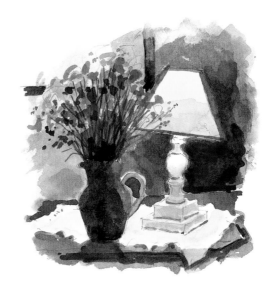

▼ Table Lamp and Flowers
48 x 36 cm (19 x 14 in)
The background clock in this watercolour is less obtrusive. The lighting is now more interesting and moody. I have included a newspaper and a pair of spectacles to provide extra interest.

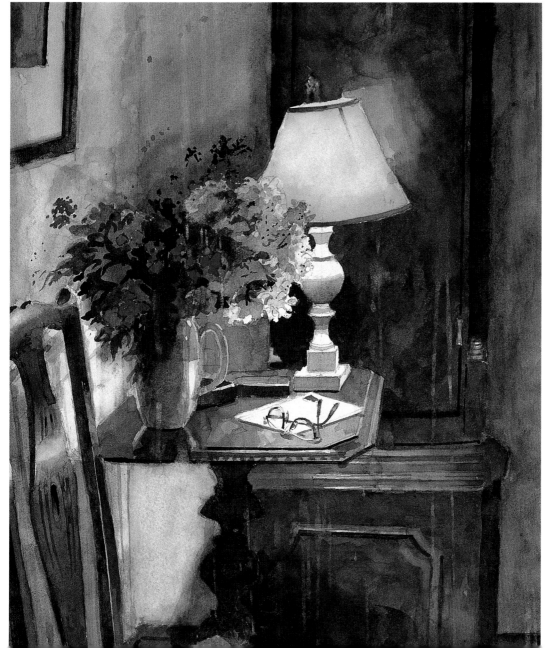

Windows and light

From the inside, a normal window can present a fascinating subject, offering an opportunity to create effects of pure light. To achieve this successfully, however, especially as a close-up subject, it is necessary to use a full range of tones from the palest of pale through to the rich, dark, low-toned colours. These may be achieved easily by building them up, gradually overlaying one colour over another, and by using concentrated mixes. It is useful to experiment with a number of colours in order to create a tonal range chart from light to dark. It can be helpful to have these to hand when you are beginning to paint window subjects.

▲ *Creating a tonal chart like this of a range of colours will help you see them not only as hues but as tones, from light to dark. I have used some Payne's Grey here to extend the tonal range.*

Light and tone

Before turning to your paints, it may be best to produce one or two tonal studies of window subjects using nothing more than a pencil. Use a 4B or a 6B and you will be able to obtain a good

▼ **Window Shelf with Jug**
13 x 13 cm (5 x 5 in)
Sunlight and shade always make an interesting subject. The angle of light rapidly changes so you must work fast, or take a photograph and use that for reference.

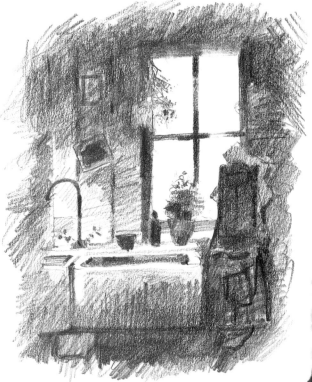

▲ *Making a tonal drawing in pencil can be a help before going on to a full-size watercolour. Leaving the subject outside the window unpainted increases the effect of pure light.*

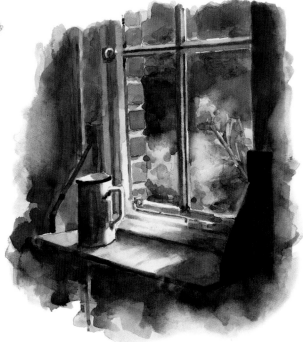

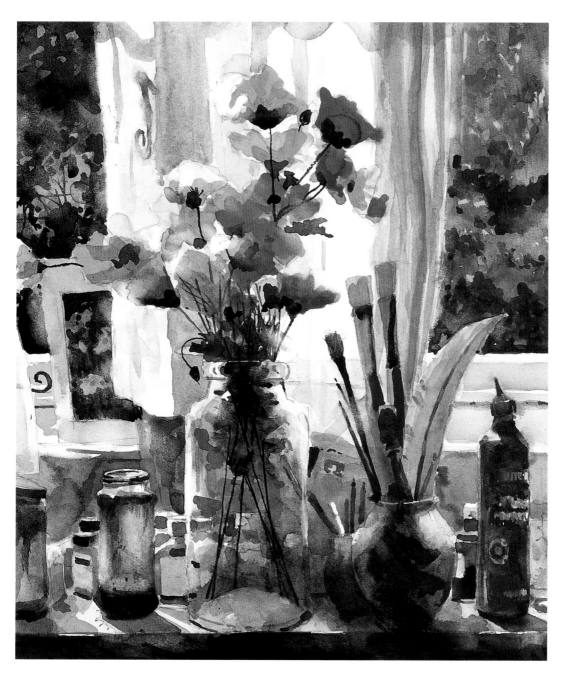

range of tonal values from light to dark. Using my drawing (opposite) as a guide, try to find a small window in your home which is not in direct sunlight. Maybe in front of it will be a table, ledge or another surface so that some light will fall on it. Make a tonal study leaving the window panes relatively clear with the surrounding unlit parts quite dark but with a suggestion of detail. Hopefully, you will be able to produce an effect

▲ **Studio Window**
38 x 23 cm (15 x 9 in)
A favourite subject of mine. Painting against the light usually produces an interesting result.

of pure white light which is similar to my own example. When it comes to using watercolour, always begin with a simple subject, perhaps only a portion of a window.

Mirrors and reflections

Mirrors have long been associated with magic and mystery. They have long been of interest to illusionists, writers of children's fiction and artists. Certainly there is something very compelling and mysterious about mirrors. The type of subject you wish to paint will govern the size and type of the mirror you will need to use. A hand mirror might be effective for featuring the reflection of a face. A larger one, approximately 61 x 46 cm (24 x 18 in), would be useful for reflecting part of an interior whereas a really big wall mirror would enable you to sit and paint yourself full length. There are many ways in which a mirror might be featured in a watercolour painting and it is worth spending some time in exploring all the possibilities.

◀ *If you choose the position of your mirror carefully, you can have a fascinating subject of light and shade.*

A matter of position

To make a mirror look like a mirror in your painting it will probably be necessary to position it so that it catches light which is different from the context in which it sits. For example, in a dark corner you could compose an arrangement where a mirror reflects a window. This could make a good subject. However, if the reflection and the space surrounding the mirror are similar, the result may look confusing.

If you want to paint somebody looking at their reflection in a mirror you will normally have to cheat. You can achieve a very realistic visual effect where your subject is actually looking at a wall but appears to be studying their reflection (see my pencil sketch above).

It can be useful to use a wide tonal range of colours from light to dark in mirror subjects. Doing so will bring out the magical qualities which they can have. Set good rich, dark tones against pale translucent colours. Lose detail in darkened shadow and soften the edges of pale tones to create images of enchantment.

◀ **Reflected Light**
21 x 15 cm (8¼ x 6 in)
This mirror reflects a wall which is in light and shade on the other side of the room. I have used some white gouache for the highlights.

▶ **Cheval Mirror**
38 x 25.5 cm (15 x 10 in)
You can use a mirror to brighten up the dull corner of a room. Mirrors like these are useful because they can be positioned almost anywhere.

People in interiors

The most ordinary activities that take place in domestic settings can make very appealing watercolours. A girl reading a book or nursing a cat can be a lovely intimate subject. If you need inspiration, look no further than the paintings of these subjects by Gwen John, even though her medium was mainly oils. Look also perhaps at the domestic bathing scenes of Edgar Degas, in pastel this time, but absolutely beautiful.

Using the medium of watercolour, similar themes may be attempted, but others may occur to you, which are more in the way of gritty realism, such as somebody cleaning a window, doing the washing up or even brushing shoes!

Making a start

If you are new to drawing and painting figures and have a mirror of a similar size to the one mentioned on page 84, you could begin in a modest way by just drawing your reflection against the light of a window. Do not concern yourself with your facial features; just crosshatch

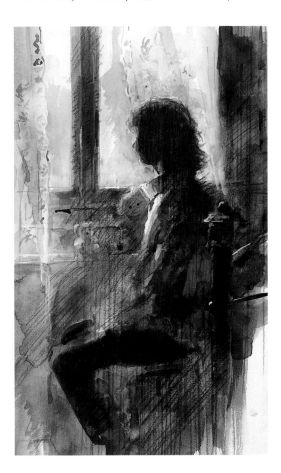

▲ Seated Figure
41 x 25.5 cm (16 x 10 in)
A figure set against a window can be a good subject for a painting. Although minimal detail can be shown, the result can be surprisingly effective.

▶ *This silhouette study was made against a small window. Little or no detail is shown.*

the main lights and darks of the subject (see page 84). Working in this way is a good introduction to getting a clothed figure down on paper in the right kind of proportion.

Using a model

A friend or family member might be encouraged to pose for you. If you have little experience in drawing or painting figures, then work against the light as before, using a minimum number of colours and some conté crayon or a carbon pencil to strengthen the lower-toned areas.

▼ **My Other Job**
42 x 27 cm (16 1/2 x 10 1/2 in)
You can make maximum use of light and shade by positioning your subject next to a window. Notice how I have hatched conté crayon over the darker areas of the watercolour.

Gradually, you may well be able to tackle more ambitious subjects, adding some detail and also introducing settings of greater complexity, possibly rivalling the great works of Degas himself!

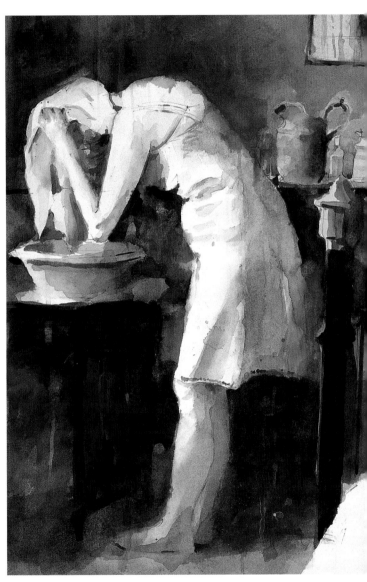

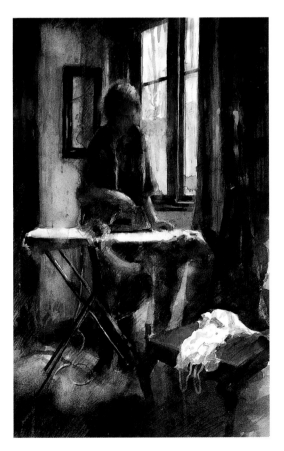

▲ **In the Bedroom**
42 x 27 cm (16 1/2 x 10 1/2 in)
Setting a strongly lit figure against a low-toned background can create a well-defined image. In subjects like these it may be best if fine detail is suppressed.

Found still lifes

Sometimes a wonderful still life subject can come into being quite by chance. It may be that an untidy room corner with some cast-aside items in intriguing combinations could have all the ingredients for a fascinating watercolour. Many such subjects might suggest an underlying theme, an event perhaps or something which just looks funny. There are lots of possibilities.

Alternatively a collection of disparate objects coming together on a table top by an act of chance might look so good that the urge to use them as your subject matter can be overpowering.

Many of the best still lifes often depend on factors other than their content. The way in which they are lit, for example, can often make them well worth painting. It is often possible to find an arrangement which looks interesting but no more than that. The repositioning of a lamp or even the partial drawing of a curtain could turn this set up into something which could be a joy for you to paint.

Keep a lookout

It is best always to keep an eye open for that ideal subject, even when painting still lifes is far from your mind. However, for the impatient, it is always possible that fate could be given a helping hand with the use of a viewfinder. Two pieces of card cut at right angles can be ideal for this purpose, enabling potential arrangements to be visually isolated. It is amazing how this simple device can be so helpful.

Look for potential subjects in all kinds of places: cupboards, shelves, racks and tool sheds. View the subjects from alternative angles, too. Vary the proportions of your viewfinder in order to obtain interesting compositions.

▼ **Still Life with an Alarm Clock**
52 x 35.5 cm (20¹/₂ x 14 in)
This collection of household items struck me as having the potential for an interesting watercolour.

▲ *Two pieces of L-shaped card will help you to isolate the potential subjects for a watercolour.*

▶ **Bathroom Sink**
34 x 23 cm (13¹/₂ x 9 in)
Sometimes it can be a good idea to reject attractive or cute subjects and to look instead for something based on harder reality.

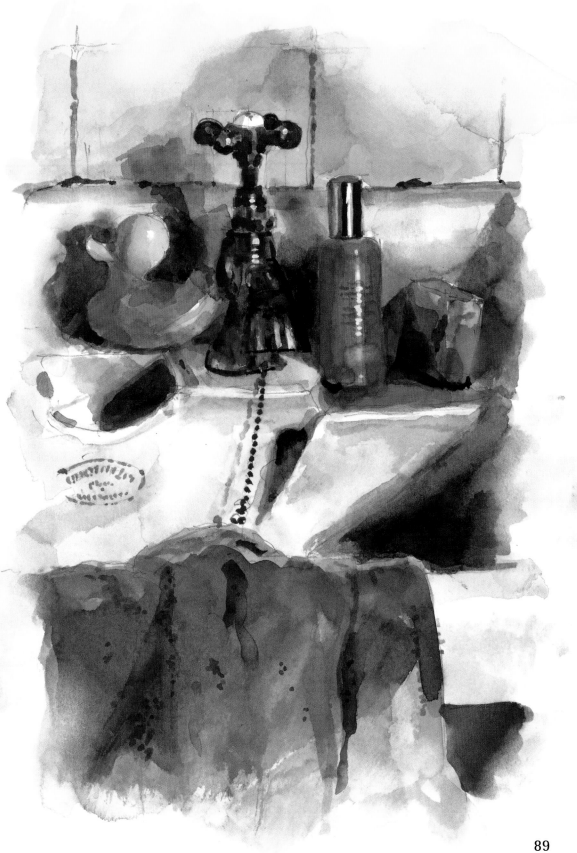

Arranged still lifes

The first consideration when you are painting an arranged still life must be your choice of items to make up the subject. A selection that has some kind of visual appeal will often become the basis of a successful watercolour.

Some of the best still lifes consist of just a few similar objects. If you are new to still life painting, then it is probably best to begin this way. Three or four pears and some leaves, for example, carefully arranged on a wooden surface in soft light and shade can make a wonderful watercolour. Similarly, glass bottles of varying size and colour can be arranged quite easily to make a very paintable subject.

Using contrast

At the other extremes, using the principles of contrast, it is possible to choose items which, by virtue of being completely different, set up some kind of tension. You could select items that are markedly dissimilar in their character or use. Alternatively, it may be possible to make use of different textures or chacteristics of materials. In this context, glassware and textiles can make a good subject. China and flowers are another successful combination. I could also imagine a marvellous subject of sea shells and jewellery.

A note on composition

When you are arranging a still life subject, aim to avoid absolute balance. If the main item in the composition sits firmly in the centre of the picture area, then the finished painting will have

▲ *The composition here is altogether too balanced and the spacing between the items is too regular.*

▲ *This is a better composition but the jugs are perhaps too evenly placed on either side of the bottle. Also the stones are positioned in an uninteresting way.*

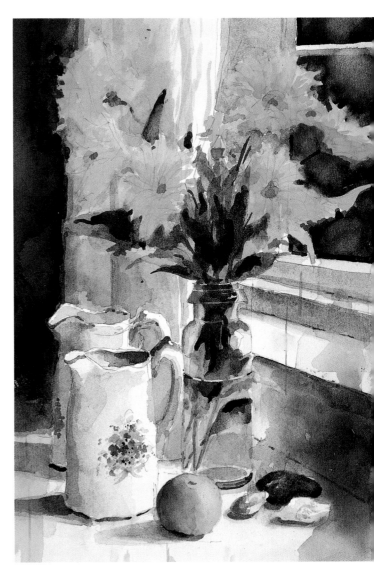

▲ **Still Life with Flowers**
35.5 x 27 cm (14 x 10¹/₂ in)
This is the final arrangement I chose. China, glass and flowers nearly always go well together, and setting the subject on a window ledge in late afternoon sunlight ensures good, gentle illumination.

▲ *The jar, jugs and apple stand on top of one another, making this composition look really awkward. Try something else!*

a static quality. However, by positioning it to one side, unequal areas of space can be created, and these will give the resulting watercolour a quality of life and energy. So before commencing a watercolour, make some small studies of your intended subject, thereby trying out a variety of different arrangements to see which works best.

DEMONSTRATION: Kitchen still life

The ingredients for a simple meal can make a very satisfactory subject for a painting. For this watercolour I made sure that I had a variety of colours, shapes and textures. In order to do this I combined metal (the knife), glass (the bottle and jars), china (the basin) and other organic materials (vegetables and pulses). This can bring out the best in the watercolour medium.

1 *I arranged the items for the still life in a rough pyramid shape and then lit the subject from the left at a moderately low angle. The preliminary drawing was made with a 4B pencil in order to create lines of a suitable density.*

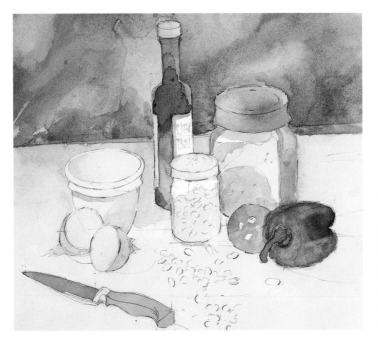

2 *I began by painting some of the basic colours in the subject. To the left and right in the foreground I laid down the palest of washes using mixes from Yellow Ochre and French Ultramarine. The background made use of Carmine, French Ultramarine and Yellow Ochre.*

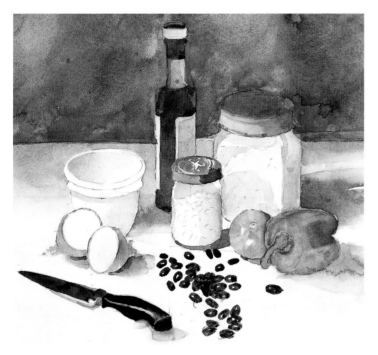

3 *I now began to build up some of the tonal values in the subject, most notably the bottle and the foreground knife. For the bottle I used Indigo, Cadmium Yellow Pale and Yellow Ochre; for the knife, Payne's Grey plus Prussian Blue; and for the handle, Payne's Grey plus some Cadmium Scarlet.*

4 *The shadows on both the inside and outside of the bowl were developed with a mixture of warm and cool greys. The cast shadows were further developed using French Ultramarine, Yellow Ochre and some Payne's Grey. The dark tone of the bottle was developed further. More Cadmium Red was washed over the tomato and the highlight was softened using a cotton bud.*

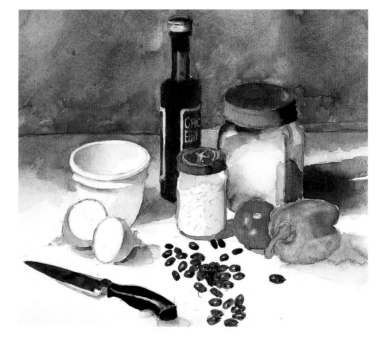

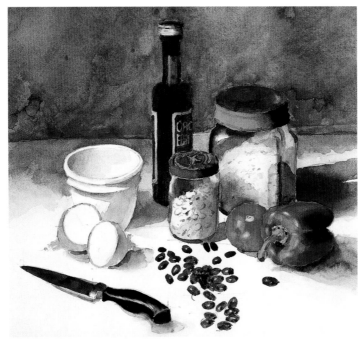

5 I overlaid Cadmium Scarlet on the pepper, further developed its area of shade and lifted out the highlights. The rice in the jar was painted with Yellow Ochre, Cadmium Red and French Ultramarine. The jar of pulses was painted with a green made from Monestial Blue and Aureolin with a light wash of Payne's Grey over the top.

Focus on details

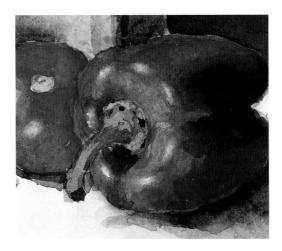

▲ The pepper and tomato: these were both painted in Carmine and Cadmium Red but in different mixes to create warm and cool reds.

▲ The basin: I mixed warm and cool greys for the basin and background using a mixture of French Ultramarine and Yellow Ochre.

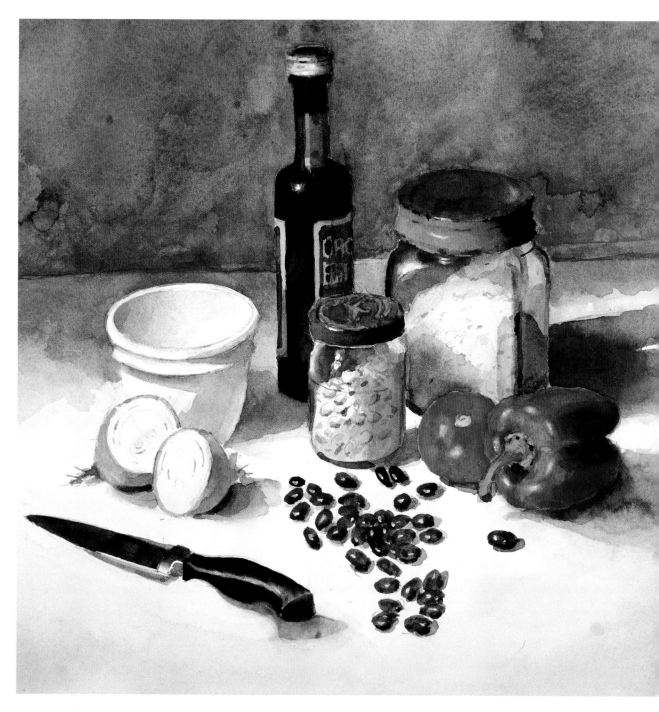

▲ Kitchen Still Life

27 x 27 cm (10^1/$_2$ x 10^1/$_2$ in)

In this final stage, I added some highlights to the
bottles and jars using Titanium White gouache.
Finally, I added a dilute Yellow Ochre wash to the
foreground of the painting.

Using different lighting

When it comes to painting just a few objects in close-up, the use of light and shade can turn an ordinary subject into something far more exciting. Try setting up a still life on a window ledge in the light of direct sunshine. It may be illuminated adequately but it may also have a flat one-dimensional quality with no modelling or sense of space. However, wait until later in the day – the evening perhaps when the

sunlight cast could be lower and at an oblique angle. The light may also be less harsh and of a warmer colour. Alternatively, rather than waiting for the sun to illuminate your subject, it can often be a good idea to locate your set up where artificial light can be used.

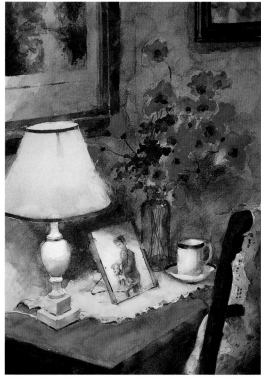

▲ Corner Table

42 x 30.5 cm (16¹/₂ x 12 in)

Including a lit table lamp in a still life can bring warmth and intimacy to the subject. The creation of shadow areas behind the lamp shade will increase the sense of strong illumination.

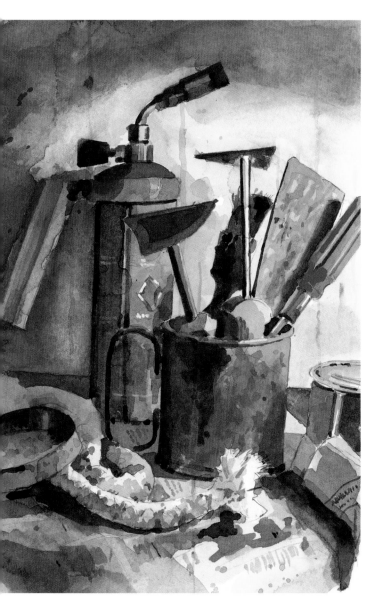

◀ A Few Tools

24 x 16.5 cm (9¹/₂ x 6¹/₂ in)

I used a desk lamp to light up this scene. Directing the light onto the wall behind throws the tools into sharp relief. I have painted the shadows in colour to avoid an overly harsh result.

A low-wattage adaptable light similar to an angle poise can be used to create all kinds of lighting from directly overhead to almost parallel with the subject. The direction, strength and angle of the lighting can have a profound effect on the mood of the subject. If lit from the side at a 45-degree angle, a satisfactory area of light and shade may be obtained, but move the lamp to a lower angle and a more dramatic or possibly ambiguous lighting can be achieved; lower still and it could create a different effect again. Why not experiment for yourself and discover what interesting possibilities present themselves?

▼ Still Life with Old Oil Lamp

23 x 30.5 cm (9 x 12 in)

The light from the window that illuminated this still life was not strong enough to create a painting with rich contrasts. I painted the background wall and shadows darker than they were in the subject. Doing this has made the highlights stand out with greater strength.

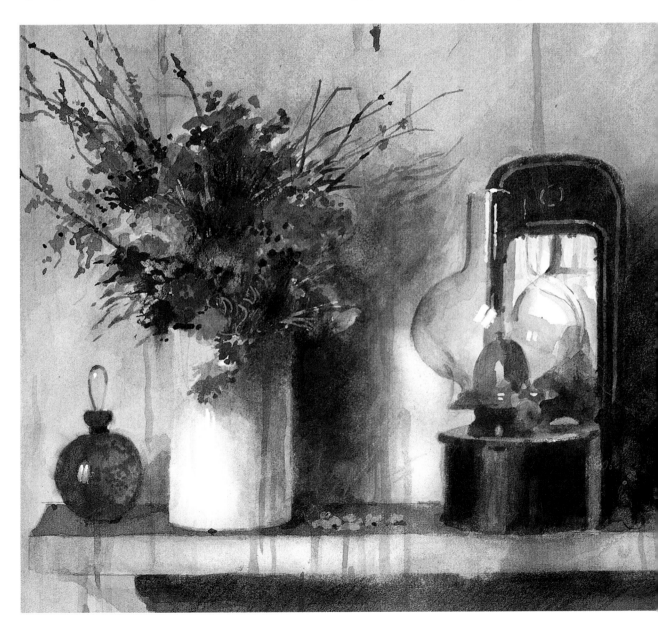

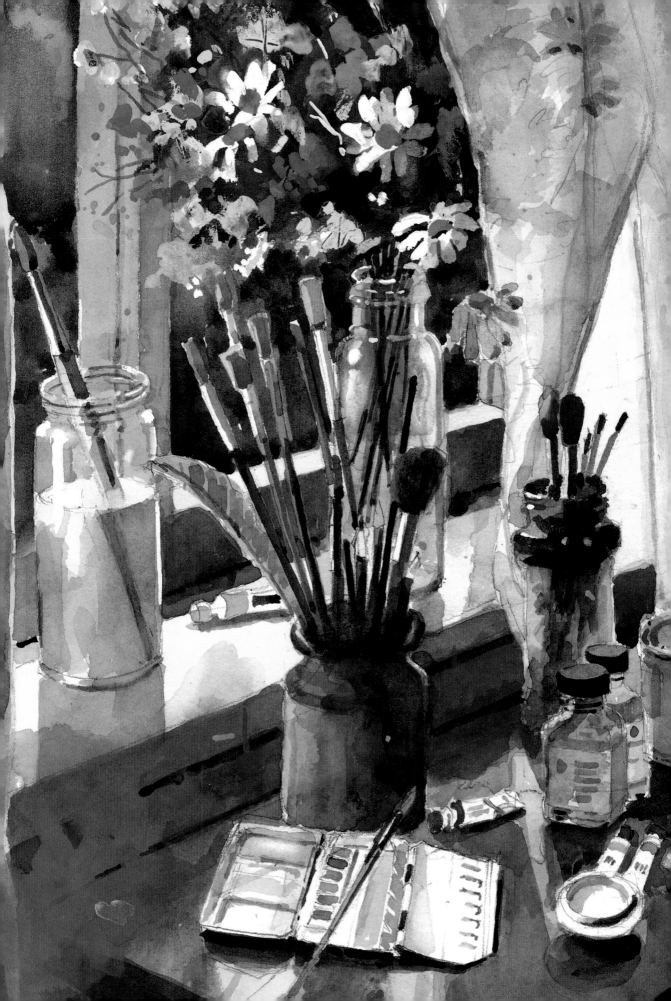

Developing Your Watercolours

Up to now it has been suggested that interesting results can come about as much from painting small-scale subjects as large, expansive ones. Furthermore, a watercolour can be eye catching even when the subject is commonplace or mundane. But subject matter need not be the only concern of the painter. In watercolour, as with other media, it is most often the quality or originality of the painting technique that makes a work successful.

Much of the following section is concerned not with subject matter but more with some of the watercolour techniques that can give looser and more dynamic results. It does not even begin to supply all the answers, but perhaps through the examples shown and the demonstrations it may be possible to see how watercolour may not only represent the subject but also create a painted surface which can be both lively and interesting.

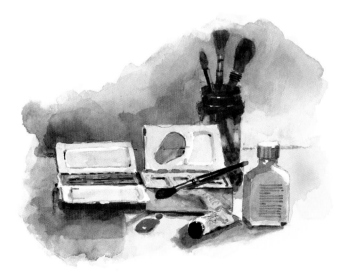

◀ **Light and Watercolour**
28 x 26.5 cm (11 x 10¹/₂ in)

Measured drawing

Many people complain that they haven't the gift for drawing, as though one can draw or one cannot; it is just a matter of chance. An alternative view is that most people can learn to draw. With an appropriate method and some patience and application, it can be possible to produce a basic measured drawing with a fair degree of accuracy.

▲ *The width of the chimney pot is being measured. When doing this, always keep the pencil parallel to your eyes and do not let it slope away from you. Failure to do this will result in inaccurate measurement.*

The pencil as a ruler

The scene here and on the following pages is of a garden pond with a chimney pot beyond. Suppose you were asked to draw only the chimney pot. The best way to start would be to close one eye and use a pencil to measure the width of the pot. Keep your arm straight out in front; do not bend your arm at all. Hold the pencil parallel with the subject and position your forefinger so that it gauges the width of the chimney pot. Now without moving your fingers, make two marks on your drawing paper which correspond with the

▼ *Assessing an angle: the apparent angle of the coping stones can be gauged with a pencil. Keep the pencil upright and do not let it slope away from you.*

space between your finger and the end of the pencil. Use the same method to measure what you can see of the depth of the pot and make similar marks on your drawing paper. You can have the basis for making an outline of the chimney which has the correct proportions.

With practice – and it does need practice – it can be possible to measure not only the width of things but also the spaces between things to build up a complete drawing.

Measuring angles

Unfortunately, the world does not consist only of features described by vertical and horizontal lines. Some forms actually slope – a roof for example – whereas others which are in themselves rectangular, when seen at an angle to the plane of vision, appear to slope. The edges of a book lying on a table may well be seen to slope one

way or another. The angle of this or any other slope can be measured by using your pencil as the hand on a clock. Align the pencil along the edge of the item you wish to measure (viewing with one eye only). When the two angles of slope are in alignment, view your pencil with both eyes and assess its angle as showing the time on a clock face. You can lay the pencil on your drawing in the appropriate 'time' position and use it as a guide. Practise these methods beginning with simple subjects at first.

▲ Initial marks: a series of pencil marks have been made to form an underlying structure for the drawing.

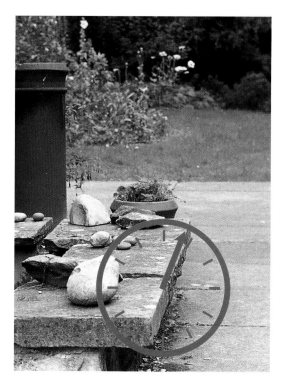

▲ When assessing an angle, you can imagine your pencil to be a hand on a clock. This angle might be judged at almost one o'clock.

DEMONSTRATION: From drawing to painting

In preparing a drawing as a basis for a watercolour it is best not to overload it with excessive detail. Fussy drawing can often lead to fussy paintings. It can be a good idea to leave some parts (foliage, for example) free from detail so that you can extemporize and permit the paint to run with a degree of freedom and looseness with only a minimum of description.

1 *The completed drawing in which the main features of the subject have been drawn, making a sufficient basis for a reasonably accurate painting. The foliage will dissolve into pure painterly abstraction.*

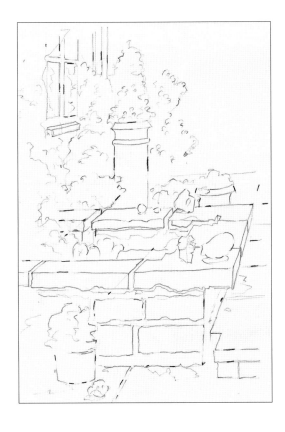

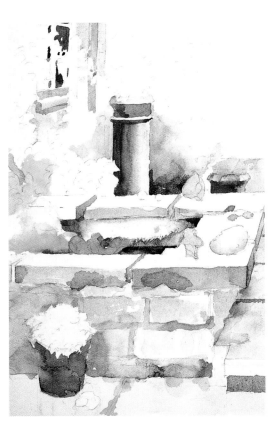

2 *I began the painting by brushing in dilute colours to establish the basic colours in the painting. At this stage I used Cadmium Red, French Ultramarine, Monestial Blue, Aureolin, Yellow Ochre and Payne's Grey.*

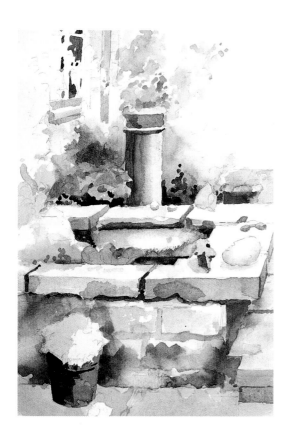

3 *I started building up the lights and darks, together with some of the detail. The greens were mainly mixed from Aureolin and Monestial Blue. I used Carmine and Cadmium Orange for the flowers.*

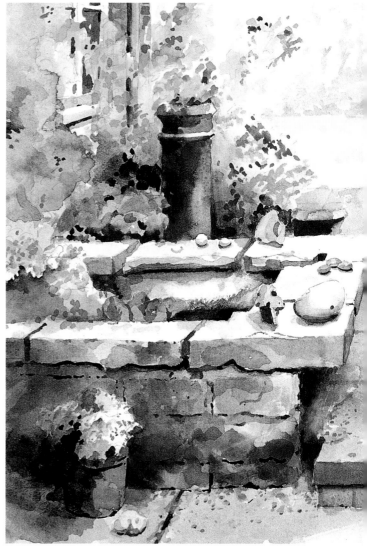

▶ Garden Pond

36 x 24 cm (14 x 9½ in)

More detailing was added and the colours were strengthened by overlaying concentrated paint mixes in shadow areas. I also suggested the presence of some trees in the background by using a mix of French Ultramarine and Yellow Ochre.

Freeing up your paintings

The medium of watercolour can create wonderfully free and exhilarating effects, yet in the hands of many practitioners it produces disappointing results. How often does one hear watercolourists complain that their work is dull or lack-lustre, in spite of their efforts to make it otherwise. It often seems that lively and loose watercolours do not come about as the result of painstaking effort.

Indeed the reverse appears to be the case. The attempt to get things absolutely right often leads to predictable, safe and unexciting results.

Loose watercolours

Watercolourists who want to paint with greater freedom should examine their current working practices and decide whether or not they need to change them. Here are some suggestions.

Details A watercolour which is freely painted is unlikely to show excessive detail. Indeed, many loosely painted watercolours show no real detail at all. Consider therefore just how much you can exclude from your paintings while still retaining the essence of the subject.

Brush size The habitual use of small brushes can lead to the unnecessary recording of fine detail – bricks in a middle-distance wall, for example, or leaves on trees. Additionally, small brushes make bitty and fiddly marks which can look laborious and awkward. Larger brushes than the ones you currently use might be better, e.g. round brushes 4, 6, 8 and 10.

◀ *This sketch was painted quickly; most of the detail was ruthlessly excluded. Paint subjects similar to this in your sketchbook, freely and loosely.*

▲ **Oil Rig in Stormy Weather**

14 x 19 cm (5¹/2 x 7¹/2 in)

This was based on a newspaper photograph. The sea and sky were improvised with watercolour paint and impasto gel. Stormy weather watercolours provide opportunities to explore the expressive qualities of the medium.

▼ **Venetian Fort at Rethymnon**

19 x 27 cm (7¹/2 x 10¹/2 in)

Quick holiday sketching is a good way of acquiring a free painting technique. Here I exploited the capacity of the medium to produce strong contrasts of lights and darks.

Paint density Try extending the range of paint in terms of its dilution and concentration. Begin a painting with broad, ultra thin washes using a large mop brush and finish it with concentrated lower-toned mixes. Even exaggerate the contrasts of tone you see in your subject.

Water and paint When an area of paint is laid down, drop some water into the colour when it is on the point of drying. You will normally obtain those characteristic water marks that can contribute to the sense of looseness (see page 8 and 106).

Paint into paint Make your colours uneven by dropping one paint into another while it is still wet. For example, a green into a yellow or a yellow into a red (see page 109).

Sketching By working in a sketchbook regularly you can develop a loose style to carry over into your paintings. Work quickly and freely. Don't worry about accuracy. Concern yourself with making the paint in the sketchbook interesting!

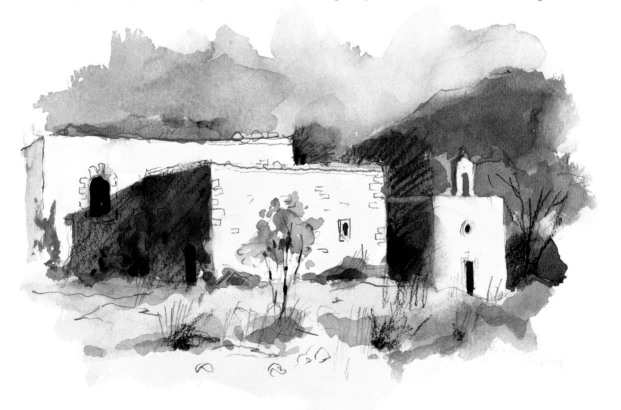

Developing a loose technique

Water, mixed with paint, allows the spread of colour over the paper surface. This might be thought to be water's only function, but there is more to it than that. Water will also control the transparency of paint. This provides the opportunity to make beautiful thin washes of colour just like stained glass. However, in addition to this, water can create a painterly quality in a work which gives it a spontaneity and freedom that other mediums often fail to match. To appreciate the role that water can

play in this medium, it can be quite useful to experiment extensively to discover its action on a wide range of pigments. It can also be useful to test out how granulation occurs and how it can be controlled.

Painting wet-on-dry

Begin by painting small-scale subjects in sketch form no bigger than 20 cm (8 in) in any direction. Prepare a drawing showing only the basic shapes. Paint washes of colour into these shapes, gradually building up colour, painting wet-on-dry. At each stage, introduce water into the washes while they are drying. Allow the watercolour to run and bleed at will. See your

▼ **Still Life with Wine Bottle**

24 x 25.5 cm (9¹/₂ x 10 in)

Water added to background washes while wet will create interesting colour shapes. Notice how I have deliberately allowed Ultramarine to run over the bottle edge.

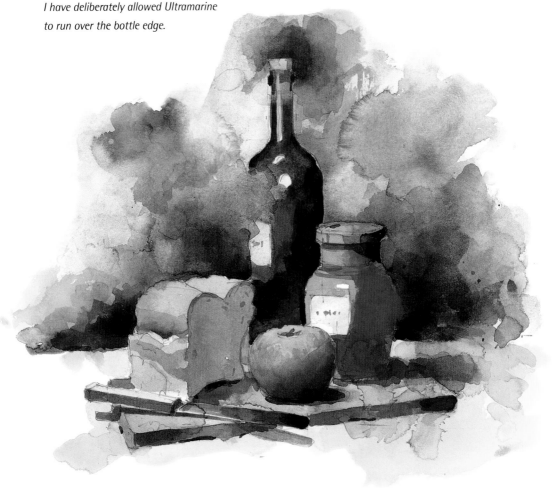

painting more as an experiment in producing interesting areas of paint rather than a photographic representation of the subject.

Watercolour sketches

Allow one wash to overlap another. Hold your sketchbook upright and allow the paint to run. Introduce low-tone colours into pale washes while wet. Avoid painting excessive detail. What you leave out is of more importance than what you put in.

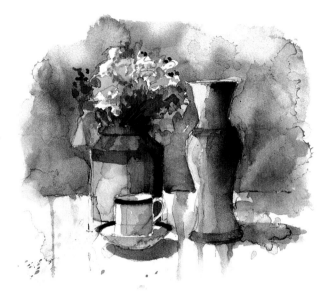

▼ *Interesting painterly qualities can come about by adding water to paint as it is on the point of drying.*

▲ *While working, occasionally hold the watercolour in a vertical position to allow the paint to run down the paper surface. This will help to create a spontaneous effect.*

▼ *Build up tones by laying one colour over another, wet on dry. Also experiment by dropping concentrated mixes into wet washes. Expect interesting results.*

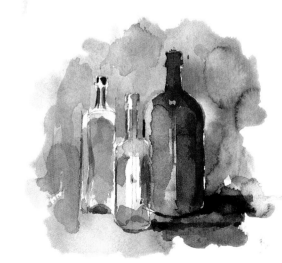

DEMONSTRATION: Using wet washes

An interior can come alive when painted freely and loosely. Detail becomes suppressed and one colour is allowed to dissolve into another. Expressive painting is being sought here, not mere accuracy. The room was rather dark and gloomy but I aimed to create a bright, colourful painting with a sense of life and movement by setting pure, unmixed colours against rich, low tones.

1 *This drawing defines the shapes and spaces in the room although it shows almost no detail. A more intricate drawing would inhibit a free and loose style.*

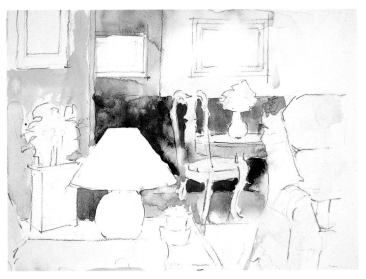

2 *I used Yellow Ochre, Cadmium Yellow Deep, French Ultramarine, Carmine and Indigo to provide these first washes of colour. I dropped clean water into the paint when it was on the point of drying to create an uneven paint quality.*

3 *Colour was added to other parts of the painting: the walls, floors and furniture. I kept the paint loose and runny and dropped concentrated colour into wet washes, allowing them to spread unevenly.*

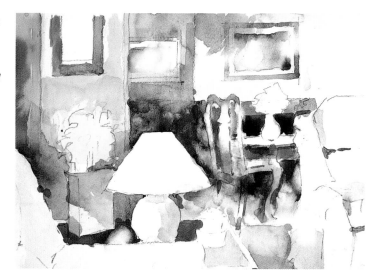

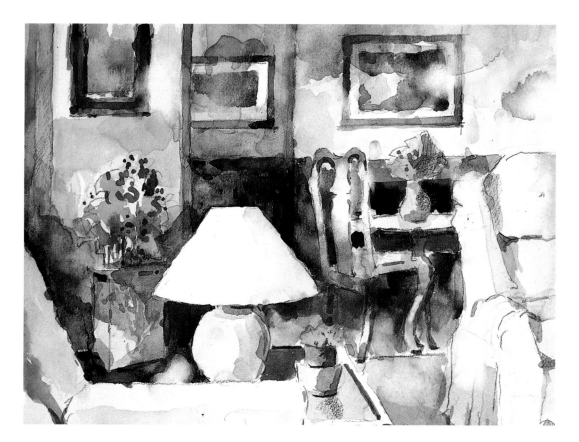

▲ **Room at the Dell**
23 x 30 cm (9 x 12 in)
Further low tones were added for the shaded areas.
Additional wet washes of dilute colour were used to break up
some of the areas of paint. A few pencil lines were drawn
here and there to sharpen up the imagery.

Expressive techniques

In addition to creating an interesting and lively painted surface by the use of loose watercolour techniques, it is possible to push the medium further. Unconventional means of applying paint to paper or methods of breaking up the image with various substances or even using abrasive methods can create striking effects.

Flicking and spattering

By virtually throwing the paint at the paper (but in a controlled manner) exhilarating effects may often be obtained. An old toothbrush loaded with paint can be the ideal means for flicking even concentrated paint. By drawing a finger over the bristles, a varied spray may be directed at the paper surface. Pigment applied in this way can be useful when painting organic subjects, such as flowers and trees.

By using other coarser means of flicking paint (a larger brush perhaps), the surface of a watercolour may be altered in order to provide some interesting results.

Using foreign substances

There are a variety of products that will break up the surface of watercolour paint at the time of application. Salt sprinkled over wet paint will create a crystalline effect. Candle wax rubbed over the paper surface will break up any imagery painted over the top. This can be useful where a textured result is required. To achieve a similar result, turpentine can be applied to the watercolour paper surface before painting.

◀ **Pitcher of Flowers**
23 x 18 cm (9 x 7 in)
A quality of organic growth and fecundity can be suggested in a flower painting by the use of paint flicking and spattering. However, using paint like this can go beyond the mere descriptive. Allow paint to spill loosely over other areas of the painting to help convey a sense of spontaneity.

Abrasive techniques

Glasspaper, craft knives and blades can be used to achieve specific effects, highlights or textures. It might be worth experimenting with methods of breaking up the painted surface to veil or partially obscure an image.

▶ **The Hat**

29 x 25 cm (10 x 8 in)

Beside conventional watercolour paint, I used petroleum jelly and soap. Interesting, painterly marks can be made using any water-resistant material. I used soap to modify the effects of the repellent. If you do want to experiment with materials like these use only your oldest brushes!

▼ **Houses at Rumburgh**

13 x 15 cm (5 x 6 in)

Another way of breaking up watercolour imagery is to use an abrasive to take parts of the painting back to the original paper surface. Pushed further this method can produce interesting imagery bordering on abstraction.

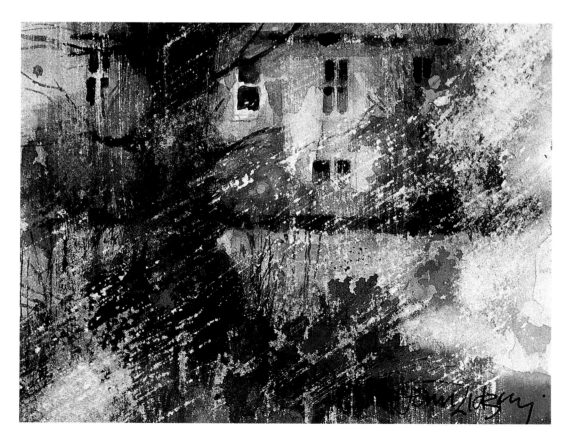

Working with light

The dullest of subjects can be brought to life by an imaginative choice of lighting. A flat landscape seen on a dull day can appear flat and uninteresting, but by the light of the evening sun it could be the subject of an evocative watercolour. Artificial light can be used in all sorts of ways to create mood. It can extend from soft and intimate right through to the harsh and frightening. Whatever subject you choose, always think carefully about how lighting can affect the outcome of your painting.

Finding a good subject

In the country, the town, at home and even in the garden, subjects with interesting lighting can take you by surprise. So keep a look out for contrasts of light and shade. A brilliant painting can result from the sun shining through trees, reflecting in puddles or even just shining through a window. Light can also cast some interesting shadows on the ground or on walls. It's a good idea to make pencil studies of these effects before painting.

Go for the unusual

Aim to be adventurous. Sit in your local church and make studies of stained glass windows. See if you can paint the essence of coloured glass. Paint your neighbour's illuminated window at night (but ask them first). Alternatively, make a study of a softly lit table setting with some candles. Make an effort to create a sense of intimacy and warmth.

Tonal values

To create the quality of strong light in a watercolour it is very important that you produce adequate tonal contrasts. Compelling results will come about when good, rich darks are built up side by side with pale, delicate

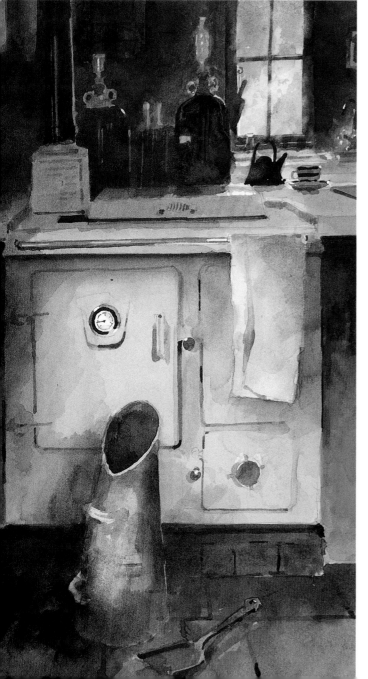

◀ **The Farmhouse Stove**
35.5 x 19 cm (14 x 7^1/$_2$ in)
The light falling on the kitchen stove, together with the background window, creates an interesting contrast of reflected light and direct light. The dark and light tones make this contrast work effectively.

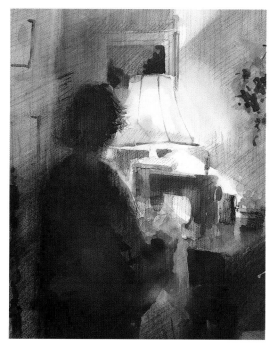

◄ **The Sewing Evening**
38 x 35.5 cm (15 x 14 in)
The silhouetted figure juxtaposed with the table lamp creates a powerful effect of light and shade. Black conté crayon adds to the low tonal values of the painting.

▼ **Poppies**
37 x 46 cm (14$\frac{1}{2}$ x 18 in)
There is no sunlight in this north-facing window but a strong sense of light is evident. This is achieved by introducing low tones at the top and bottom.

washes of colour. Low tones are best created by building up colours painting wet-on-dry – possibly three or four applications. Alternatively, crosshatching black conté over previously laid down watercolour is a good way of creating strong dark tones while producing an interesting textural effect.

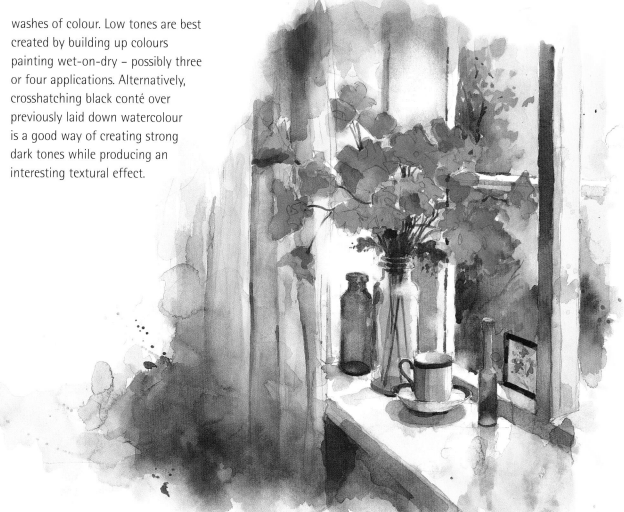

Dramatic light and shade

Watercolour is not normally associated with chiaroscuro lighting effects. The oil painter with a greater range of available tones is better placed to produces scenes of powerful light and rich darks. However, the watercolourist who is prepared to create such low tones as the medium can offer can certainly bring to life light and shade effects.

Lighting for interior subjects

If strong contrasts of light and shade are required, localized electric lighting can be the best way of achieving it. A table lamp can cast a pool of light where a series of items is arranged. Glass, china or coloured textiles, for example, can reflect brilliant colours and provide a contrast to areas of deep shadow outside the pool of light. The result can be deeply satisfying.

For room corners and interiors, electric lighting can be used but it is always best to avoid fluorescent lighting which is flat and antithetical to dramatic lighting of any sort.

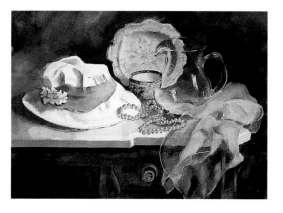

▲ **Still Life with Hat**
17 x 25 cm (7 x 10 in)
Set up close to a window, the depth of tone of the background was exaggerated to create bright light.

Natural lighting provides strong illumination with deep shadows. A subject close to a door or window can be wonderful to paint, especially a still life or figure lit from the side in a window space. If you are looking for a really dramatic lighting set-up, paint towards a window with your subject in complete or half silhouette.

Public spaces

Really atmospheric lighting may also be found in such places as railway stations, factories and theatres. Painting or even sketching in places like these might be out of the question but working from a photograph is always a consideration.

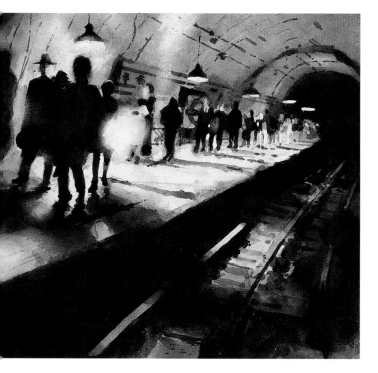

◄ **Going Underground**
20 x 25 cm (8 x 10 in)
Be on the lookout for unusual lighting in public spaces. This disused railway tunnel was illuminated by some low hanging lights which gave an eerie effect.

▶ **Wild Flowers by the Window**
42 x 27 cm (16½ x 10½ in)
The area of shadow at the base of this painting is exploited to create added luminosity around the flowers.

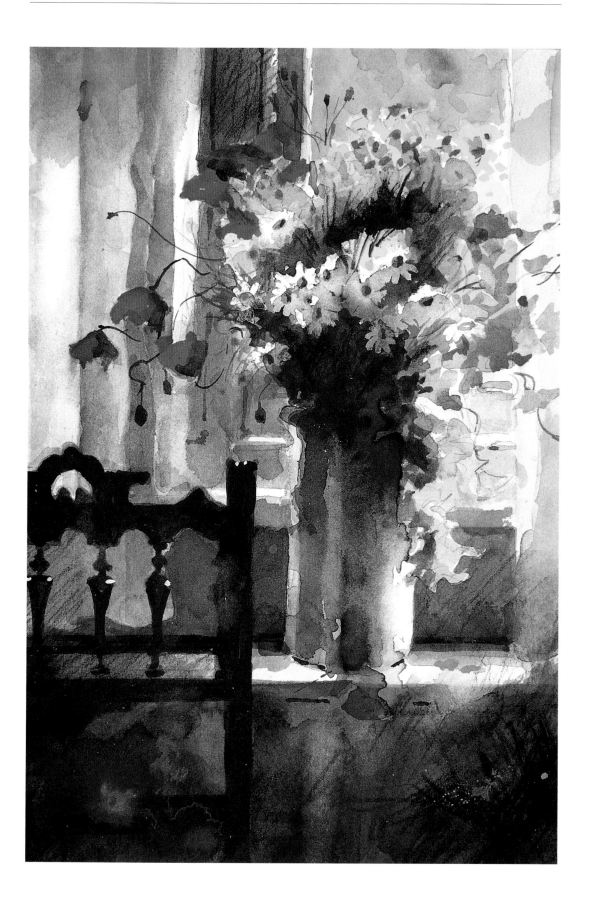

DEMONSTRATION: Interior light

This shows how to use tonal values to create a sense of light and shade and how by setting pure colour tints against rich dark tones a quality of radiant luminosity is possible. The figure and curtains are illuminated by the light from the window while the rest of the room is almost in darkness. The girl's head is in total shadow creating a hint of mystery.

1 *In this drawing it is only the blouse and the upper part of the figure which show any real detail. Other areas were extemporized during the painting process.*

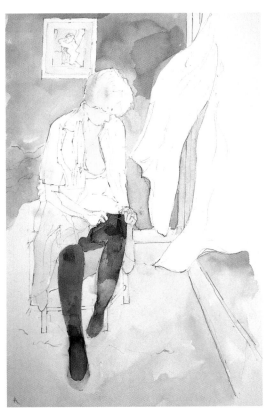

2 *Areas of dilute paint were laid down to establish the main colours to be used in the painting: Carmine for the blouse, Yellow Ochre for the floor, Cadmium Yellow Pale and Monestial Blue for the bed covers and Indigo for the wall.*

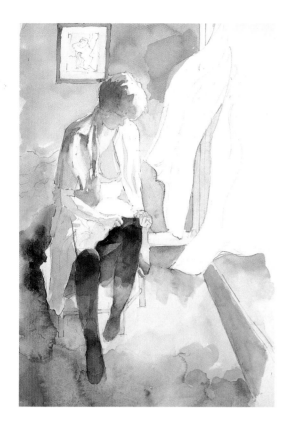

3 *I darkened the shadow areas of the blouse with mixes of Carmine and Burnt Umber. The light areas of flesh colour were dilute Yellow Ochre mixed with Cadmium Yellow. The immediate foreground made use of Yellow Ochre, Carmine, Burnt Umber and French Ultramarine in various mixes. The colours were applied very wet at this stage.*

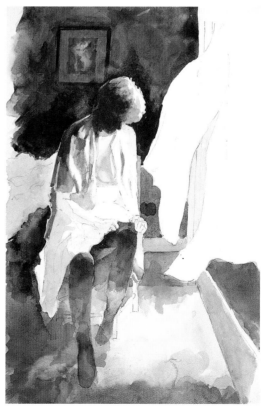

4 *I built up the tonal values of the background, floor and the upper part of the figure. For the wall, I used mixes of Indigo, Cadmium Yellow Pale and some Payne's Grey; for the foreground, mixes from the colours used in Stage 3, but in a more concentrated form. The girl's head needed a low-toned warm colour. I used Yellow Ochre, Carmine, Payne's Grey and French Ultramarine.*

Focus on details

▲ *On this area of the floor, just under the curtains, I have allowed paint to run and dribble to break up an otherwise flat area. I have used Cadmium Yellow Deep, Yellow Ochre and Indigo here.*

▲ *I have used tonal values quite carefully here. Although the girl's skirt was in deep shadow I kept it light to create strong contrasting tones so that the upper part of the arm retained its clarity.*

▶ **Girl with Black Stockings**
46 x 28 cm (18 x 11 in)
The girl's skirt was painted in a mix of French Ultramarine and Monestial Blue, darkened in shadow with the addition of Payne's Grey. To create a quality of looseness in the shadow areas, I overpainted patches of Cadmium Yellow Pale over the background; with Cadmium Red, Cadmium Orange and Cadmium Yellow Deep over the floor area.

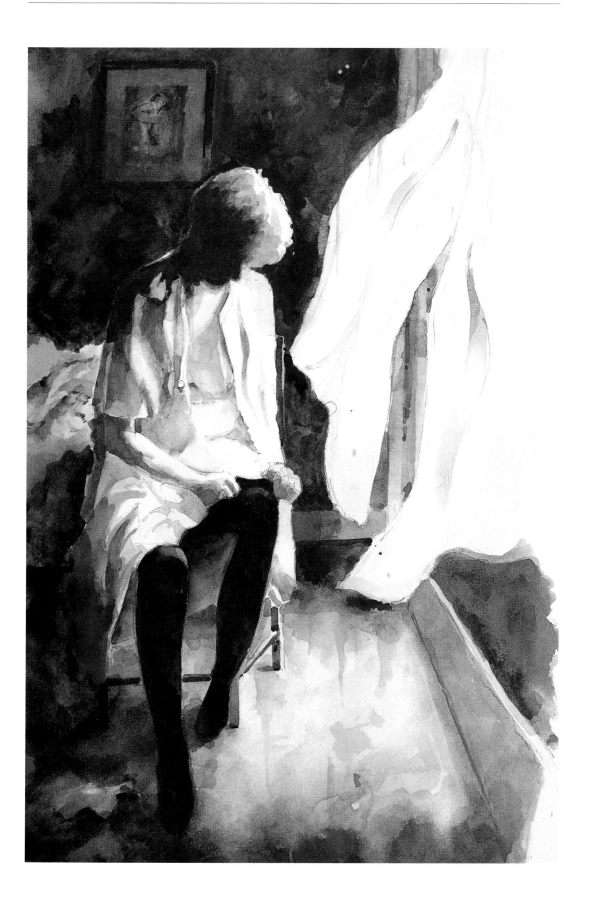

Hue, tone and intensity

To be able to discuss the subject of colour without too much confusion, it is often best to define the three terms that are usually used in such discussions: hue, tone and intensity.

Hue It is possible to talk about a colour in terms of its hue. This means pure colour independent of any other description that might be made of it. Thus items might be described as yellow, green or red, etc. or that the sky is blue.

Tone The lightness or darkness of a colour is referred to as its tone. A sky may be blue but its tone may be light or dark. Less or more water is the normal way of adjusting the tone of a colour from its darkest point.

Intensity This term refers to the brightness of a colour. Some colours are naturally intense (bright), and thus Cadmium Scarlet is intense while Burnt Umber is less so. To reduce the intensity of a colour, add a small amount of complementary colour to it or some Payne's Grey. If the sap green you used for an area of grass seems too bright a tiny amount of Cadmium Red will reduce its intensity.

▼ Circle Line Train
20 x 23 cm (8 x 9 in)
The yellows in the foreground are light in tone and high in intensity. The blue/green patches in the middle distance are slightly lower in tone but maintain a relatively high degree of intensity. Aim to analyze colours in this way.

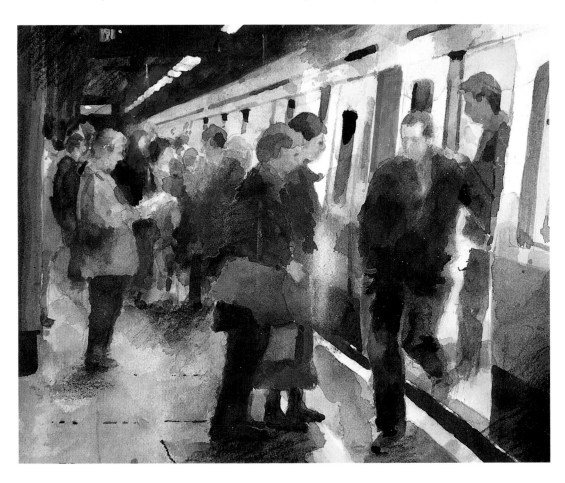

Payne's Grey

Cadmium Red

Monestial Green (phthalo) + Cadmium Red

Cadmium
Orange

Burnt
Umber

▲ *The tonal value of colours can be reduced by adding water as shown here. Bright colours can be reduced in their intensity by the addition of a complementary colour. Some colours vary in their natural intensity. Cadmium Orange is more intense than Burnt Umber.*

Colour composition

By using the tone and intensity of a colour, it can be possible to create a focal point for a watercolour. For example, by using low-intensity and low-toned colours, bordering maybe on monochrome, it can be possible to arrange just one or two items in the composition using pale high-intensity colours which will make them the centre of attention.

Alternatively, a sense of depth may be created in some subjects by using high-intensity and light-toned colours in the foreground and some low-intensity, low-toned colours in the background of the painting.

Tone and light

Where a quality of light is to be conveyed, it can be achieved by creating strong contrasts of tone. Try painting objects or features in the light using pale tones whereas in shadow areas you can use

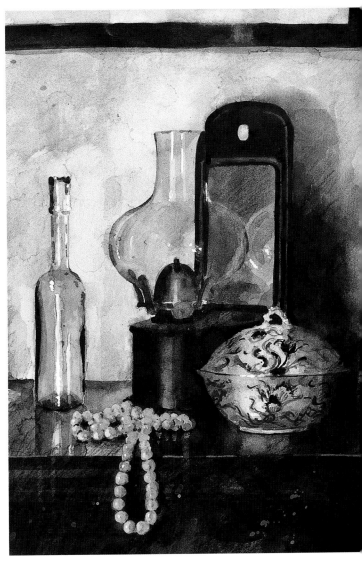

▲ **Yellow Beads**
38 x 30 cm (15 x 12 in)
The light tone and relatively high intensity of the yellow beads make them stand out strongly against the darker tone and low intensity of the surrounding blues and greys. Using hue, tone and intensity in this way can make for interesting paintings.

rich, low tones. You can obtain low tones with concentrated mixes of colour or by building up successive layers of paint (see also page 127). Excessive amounts of pigment built up in a shadow can develop an unpleasant shine, so make sure you don't overdo it.

DEMONSTRATION: Managing tonal values

Loose washes can impart a wonderful quality of zest and vitality but sometimes it is desirable to keep paint under more control. This subject determined a more organized approach with less free paint application and wet washes. It was painted under a cloudy midday sky which made it look rather flat but by using contrasting tonal values, I created an effect of strong light and shade.

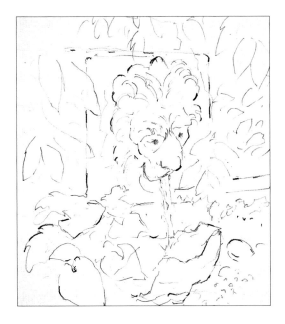

1 *The drawing of the lion's head was careful but I allowed for a certain amount of improvisation in painting the foliage and some other parts of the subject. This drawing was made with a 4B pencil. Avoid using hard pencils when making a drawing as preparation for a watercolour. If pressed into the paper, a hard pencil might make indentations into the surface.*

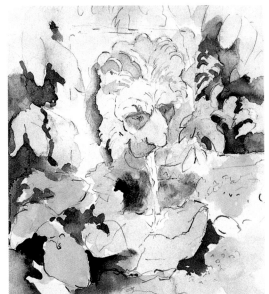

2 *The first washes established the main areas of colour and some of the tones. I mixed warm greys using Payne's Grey, French Ultramarine and Cadmium Red. The yellow/greens were made from Cadmium Yellow Pale and a small amount of French Ultramarine.*

3 *A further build up of tones. I used blue/black (Indigo and Payne's Grey) around the head, and low-toned browns around the stones (Cadmium Red, Burnt Umber and some Payne's Grey).*

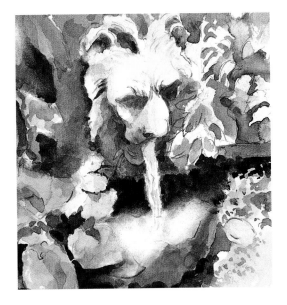

Focus on details

▲ *I used a sharp craft knife to suggest splashing water (see page 111 for another way of abrading the paper surface).*

▶ **The Lion Fountain**
33 x 24 cm (13 x 9¹/₂ in)
I substantially increased the tonal values and introduced some reds and yellows into the painting to provide a little colour contrast.

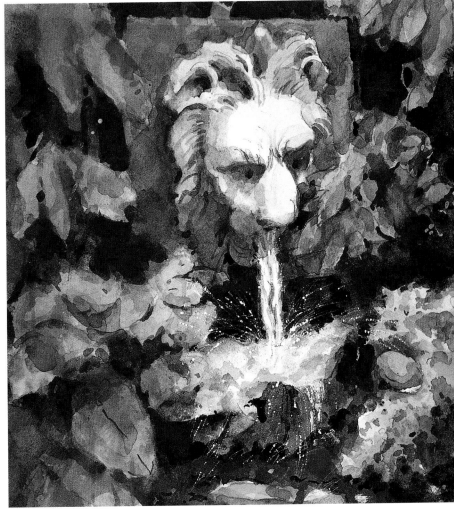

Using colour creatively

Some people have an instinctive feel for colours and seem to be able to create them in their paintings in a way that just seems to work while others have more of a struggle. For such people a simple colour wheel might be a very useful tool. In some cases, while working on a watercolour, it can be very easy to paint such a wheel in the corner of the paper. Merely draw two triangles, one inverted over the other. This will give six points on which, in clockwise order, you can dab out six colours: red, orange, yellow, green, blue and violet.

If you can paint this wheel from memory you will have a permanent knowledge of which colours are opposites (complementary) and which have common features (analogous). It can be seen, for example, that yellow is the opposite of violet and that orange is mixed from red and yellow.

Practical applications

Creative use of colour might come about where a still life is painted in blues and greens and a small amount of orange is added (the complementary of blue) to make the painting come alive. In a landscape where the predominant colours are warm yellows and reds, small amounts of blues and greens can perform the same function. Some colours are bright, others are duller. Make bright colours less bright by adding a complementary colour. A dab of blue into orange will make it less bright (or intense). Use your colour wheel to select the colours you need to control your mixes.

▶ *A simple diagrammatic colour wheel in clockwise order: red, orange, yellow, green, blue and violet.*

▼ *A, B and C are analogous colours (adjacent on the colour wheel); D, E and F are complementary colours (opposite on the colour wheel).*

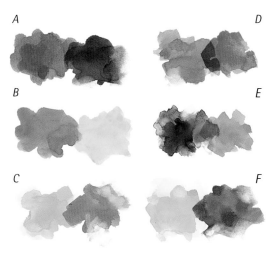

A

B

C

D

E

F

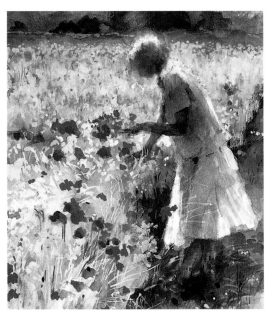

▲ **Girl Picking Poppies**
28 x 18 cm (11 x 7 in)
In this painting, warm blues and greens make a satisfying contrast to the reds, ochres and browns in the cornfield (near complementaries).

▶ **Still Life with Blue Plate**
38 x 30 cm (15 x 12 in)
Violet and yellow (complementary colours) have been used but degraded (dulled) to make them work together.

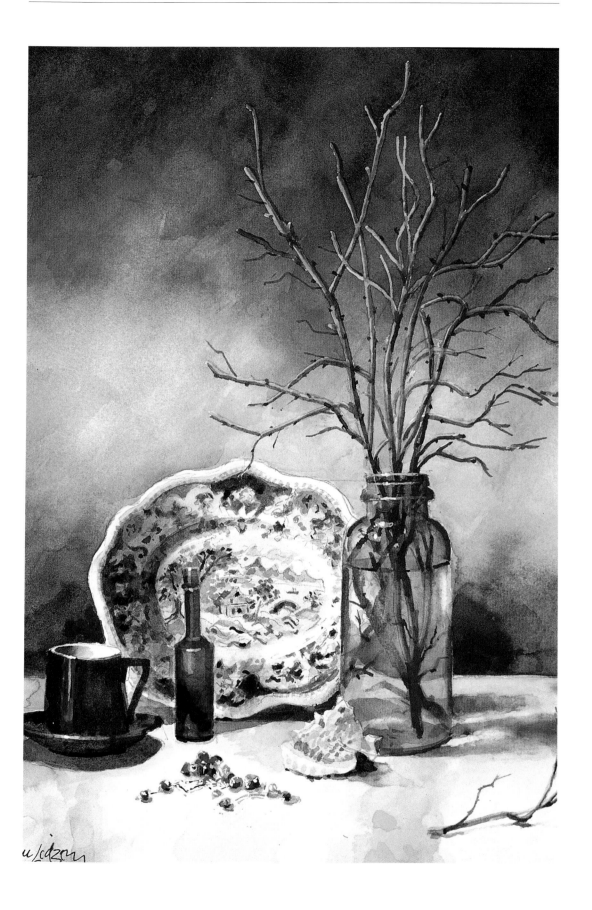

Overlaying colour

One of the delightful features of watercolour is its capacity to imitate the qualities of stained glass. One colour laid over another, painted wet-on-dry, will, under the right conditions, create a third colour in a way that would occur with two layers of stained glass. Many watercolourists exploit these effects to create paintings of great colour and luminosity.

Intriguing effects

The usual purpose of overlaying a colour is to build up its tonal value. This might be accomplished by overpainting up to three or four layers, wet-on-dry. But it is useful to remember that by varying the hue and paint concentration of the successive layers, an

◀ *Use colours in weak dilutions to achieve the maximum degree of translucency. Paint one colour over the other wet-on-dry.*

▶ *Gouache is a water-based paint and will effectively cover all underlying colours.*

uneven effect might be produced together with some intriguing and colourful effects.

Experiment by introducing water into a fresh layer of wet paint or adding another colour and then watching the chemistry of two pigments interacting. By mopping out and blotting out overlaid colours, a free and loose paint surface may be obtained, and if overlaid colours are used in unexpected or unusual ways the result can lead to wonderful and magical watercolours.

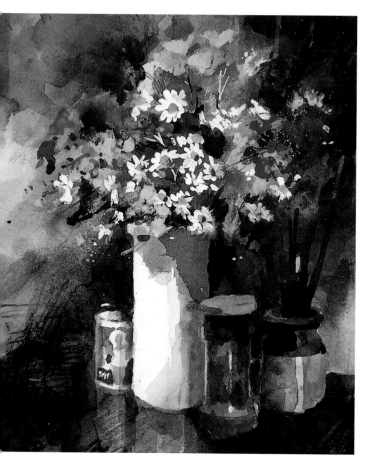

◀ **Wild Flowers in the Studio**
32 x 25 cm (12¹/₂ x 10 in)
Coloured and white gouache paint have been overlayed here to suggest wild flowers. To achieve full opacity, gouache should be diluted with only a little water.

▶ **Cello Practice**
31 x 19 cm (12 x 7¹/₂ in)
Watercolour may be freely laid over other colours to provide a painterly effect. You can use paint in various dilutions, allowing it to blend with and cover the underlying applications.

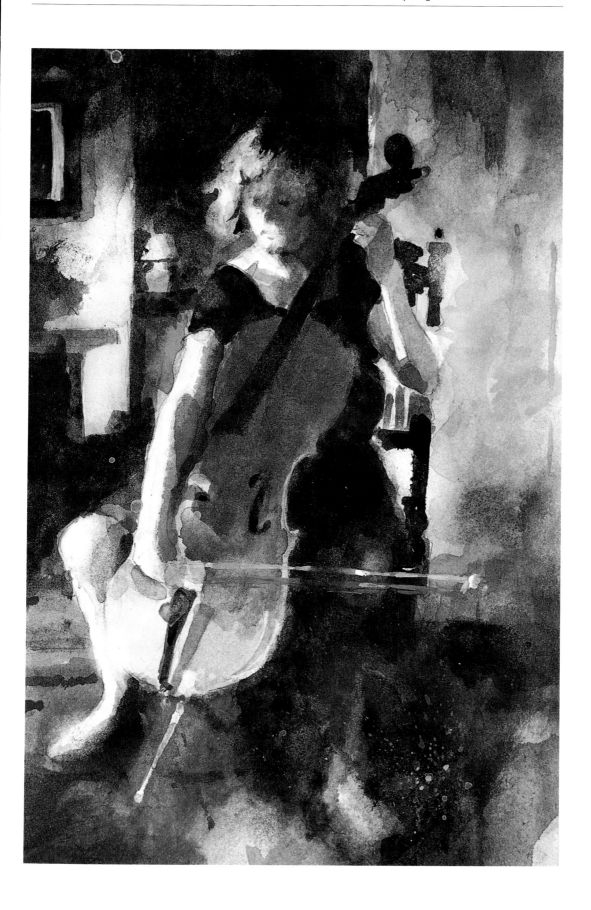

Index

Page numbers in *italic* refer to captions